RAILROADS AROUND CHICAGO

MIKE DANNEMAN

First published 2024

Amberley Publishing
The Hill, Stroud
Gloucestershire, GL5 4EP

www.amberley-books.com

Copyright © Mike Danneman, 2024

The right of Mike Danneman to be identified as the Author of this work has been asserted in accordance with the Copyrights, Designs and Patents Act 1988.

ISBN 978 1 3981 0321 4 (print)
ISBN 9781 3981 0322 1 (ebook)

All rights reserved. No part of this book may be reprinted or reproduced or utilised in any form or by any electronic, mechanical or other means, now known or hereafter invented, including photocopying and recording, or in any information storage or retrieval system, without the permission in writing from the Publishers.

British Library Cataloguing in Publication Data.
A catalogue record for this book is available from the British Library.

Origination by Amberley Publishing.
Printed in the UK.

Introduction

One of the first American settlers, Indian trader John Kinzie, established his camp at the mouth of the Chicago River where it flowed into Lake Michigan in 1803. On the opposite bank to the Kinzie home, the United States government located Fort Dearborn. Otherwise, the location saw little other growth until Congress authorized construction of the Illinois and Michigan Canal in 1827. This canal was to connect the Great Lakes to the Mississippi River via the Illinois and Chicago rivers and formally established the town of Chicago at its eastern end. As the canal was slowly being dug, a new mode of transport was emerging.

Initially, railroads were not constructed to Chicago, rather they were built out of Chicago. Its location at the southern tip of Lake Michigan put it at the end of a ship route from New York City and the American east coast via the Erie Canal (completed in 1825) and an all-water route via the Great Lakes.

The first railroad was the Galena & Chicago Union, chartered to build tracks to lead mines at Galena in northwestern Illinois, with the first tracks laid in 1848, the same year the I&M Canal was completed. The finished canal provided transportation, but it couldn't reach out and expand like a railroad, marching in every direction on mostly the tabletop-level Illinois terrain. Other railroads were soon built linking Chicago with agricultural areas west and north, with many of these later considered 'Granger' railroads. Some railways looked even farther west, with sites on the Rocky Mountains or the Pacific. At the same time, eastern railroads slowly pushed through the Appalachian Mountains separating the eastern states with the Midwest, setting a preferred course for Chicago. These eastern railroads generally didn't go west of Chicago since western roads were already there first – a big part of why Chicago developed into the most important railroad center in North America.

From 1837, when Chicago was incorporated, to 1850, its population grew from 4,170 to 28,269. With railroads, industry, agricultural products and other commodities, everything about Chicago was burgeoning. In the nineteenth century, grain, meat and lumber funneled through Chicago in amounts unprecedented in human history, largely thanks to the expanding railroads. In 1880 it was home to a half million souls, exploding to over a million by 1890. Railroads crisscrossed the city that grew to 190.638 square miles by 1900. Chicago was the farm machinery capital of the world at this time. Manufacturing these machines meant that iron and steel was needed, which led to establishment of steel mills in the area.

As Chicago became the hub of North American railroading, it became attractive to more industry, warehousing and commerce – and developed a train-riding culture that also created unmatched congestion. By the dawning of the twentieth century, Chicago was home to 2,572,900 inhabitants and had 1,294 trains arriving and departing every day. With all the different railroads serving Chicago, six major stations were built along the southern and western perimeter of the Loop, adding to the gridlock. Chicago's famous 'Loop' is the main section of downtown, central business district and commercial core. Interestingly, if a

traveler was going beyond Chicago in any direction, it usually required a hurried cab ride to another station.

By 1909, city ordinances required grade elevation for around 75 per cent of the rail lines inside city limits – 149 miles of trackage! These grade separations eased traffic jams in the city, but not in the surrounding suburbs, and did nothing to help with congestion between the rail lines themselves. At that time, railroads were more concerned with selling transportation to where their rails went. Goods needing to go somewhere else were unloaded at their freight house and drayed across Chicago, first on horse-drawn wagons and later trucks, to the dock of the outgoing carrier. Eventually, interchanging cars directly between railroads became common. In 1910, the railroads in Chicago created the Chicago Switching District, where railroads agreed to interchange and switch cars at uniform rates within the district. Several belt lines built earlier flourished and helped accommodate this traffic. New yards were built inside the district to take advantage of these belt railroads.

Continued growth of the steel industry saw new mills built, especially along the shore of Lake Michigan into neighboring Indiana. The advent of kerosene lamps and later the automobile added more industry to the region, with refineries and an auto assembly plant. Chicago became a center for the manufacture of freight cars, passenger cars and diesel locomotives, with entities such as Pullman Company and Electro-Motive Division of General Motors erecting sprawling plants in the Chicago area. All of this growth just added to the tonnage moved by railroads.

After the Second World War, inroads by trucking and construction of highways began changing how railroads did business. Freight houses and some yards became obsolete with the growth of intermodal and the industry's slow service of railroad interchange began the expansion of run-through trains between different railroads. Passenger travel was eroding too, as people took to the skies and switched to the commercial aviation. Railroads wanted out of the unprofitable passenger business and finally got their wish with the coming of Amtrak in 1971. Mergers between railroads changed the complexion of the railroads into Chicago, consolidating and removing some routes and yards in the city.

At the dawning of the twenty-first century, railroading in Chicago is still staggering and mesmerizing. Over 500 freight trains battle their way through Chicago every day. Chicago is the hub of Amtrak, and also ranks second behind New York City for the volume of commuter rail passengers carried each day on 700 scheduled Amtrak passenger trains and Metra commuter trains per day. More than 37,500 freight cars and 20,000 intermodal trailers and containers move through 125 interlockings on 893 route miles of track. Over 30,000 cars are switched at fifty-seven yards. Each weekday all of this activity – around one-third of all rail traffic in the US – makes Chicago the rail capital of the world.

Growing up in the nearby state of Wisconsin, I enjoyed many years photographing colorful and exciting Chicagoland railroading. All photos in this book were taken by myself from 1982 to 2019, organized in chronological order. I missed a lot of spectacular railroading in Chicago, like pre-Amtrak passenger trains and classic railroads that merged and disappeared years ago. I guess we can all say that about some interest we find dear to the heart. One thing hasn't changed though – Chicago is still an incredible railroad centerpiece.

Mike Danneman

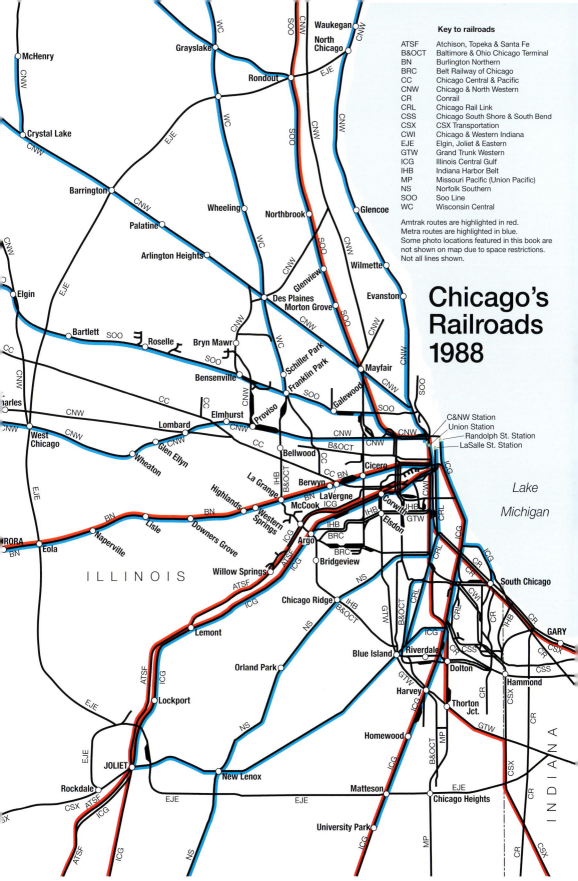

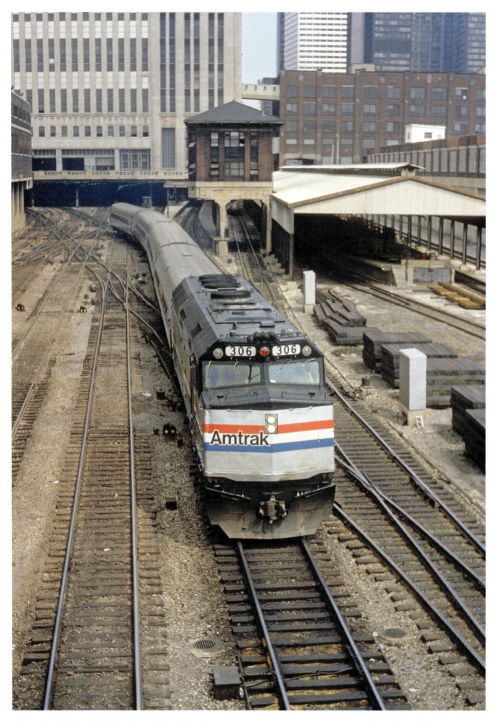

Amtrak EMD F40PH No. 306 pulls a four-car passenger train equipped with Amfleet cars out of Chicago Union Station in May 1982. This view is from Polk Street overpass, with Harrison Street Tower in the background, which is no longer used today and is totally encased in a new post office building.

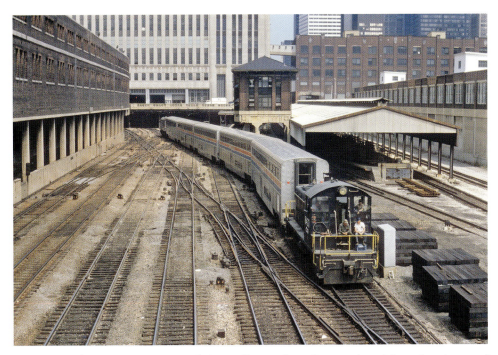

Black Conrail EMD SW1 No. 8433 brings a five-car Superliner-equipped Amtrak train out of Chicago Union Station past Harrison Street Tower on a warm springtime day in May 1982.

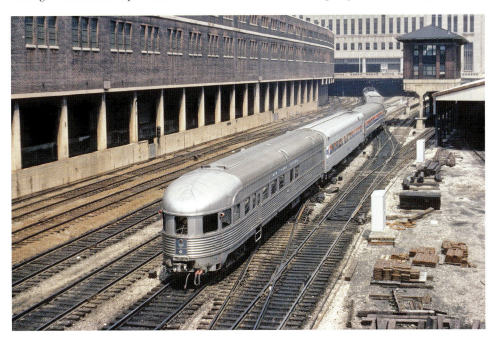

New York Central tavern-lounge-observation car No. 48 trails an Amtrak train into Chicago Union Station in May 1983. This private car was frequently seen on Amtrak trains in and out of Chicago during this era. A new post office building was built over the tracks at this location, making this entire scene no longer possible from the Polk Street overpass.

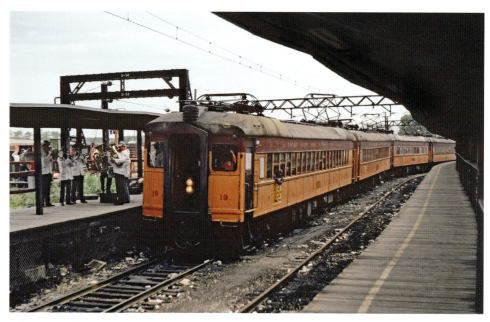

A brass band greets the last run of the Chicago South Shore & South Bend's old interurban cars into Chicago's Randolph Street station on 25 September 1983. The six-car special train is led by coach 19, built by Pullman in 1927. All of these old cars were retired by CSS&SB, replaced by a new fleet of stainless-steel cars built by Nippon Sharyo in 1983.

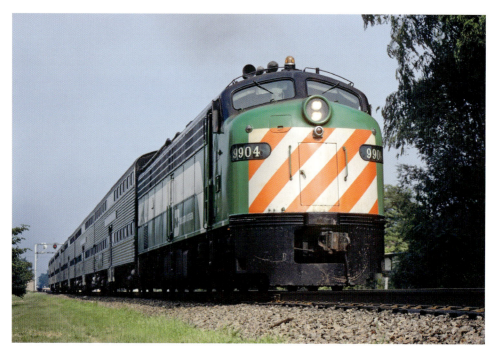

A Burlington Northern commuter train storms west after a quick stop at Stone Avenue in La Grange in August 1983. These EMD E9 passenger locomotives were in commuter service on BN's Chicago to Aurora line until 1992.

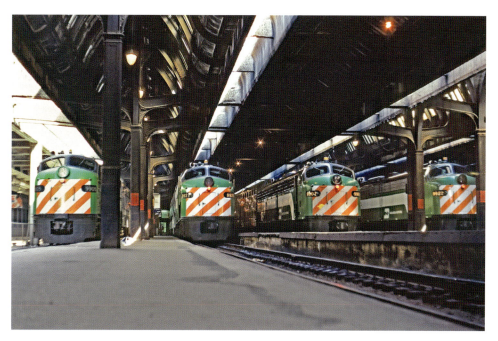

Burlington Northern EMD E9s line up with commuter trains at Chicago Union Station in October 1983, waiting patiently for the workers of the 'Windy City' to board for a trip home to the western suburbs.

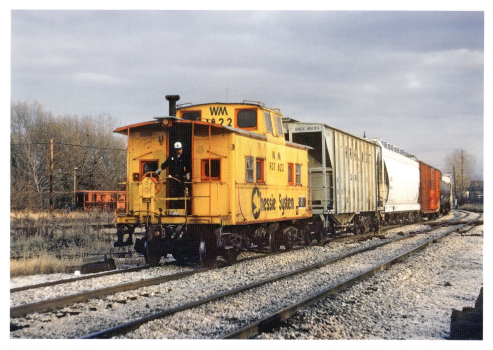

An eastbound Chessie System (Baltimore & Ohio) freight passes through State Line Interlocking trailing Western Maryland caboose No. 901822 toward the end of a November 1983 day. This busy location is around 19 miles southeast of the loop on the Illinois–Indiana state line.

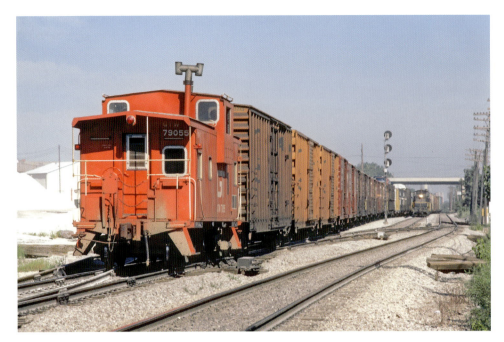

Grand Trunk Western caboose trails a northbound GTW freight at McCook in August 1984. The train just crossed the Santa Fe main line, and in the background a southbound Indiana Harbor Belt freight approaches the interlocking.

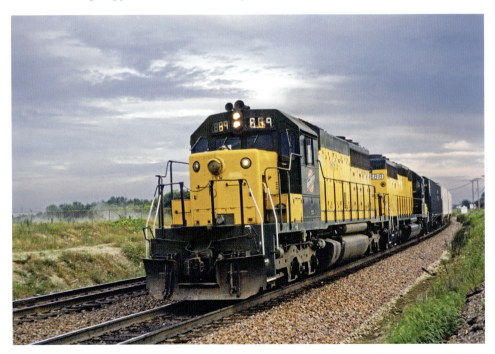

Chicago & North Western frequently utilized its freight line that skirted the west end of the runways at O'Hare International Airport. In August 1984, a C&NW freight led by EMD SD40 No. 889 heads north at Bryn Mawr, bound for Wisconsin.

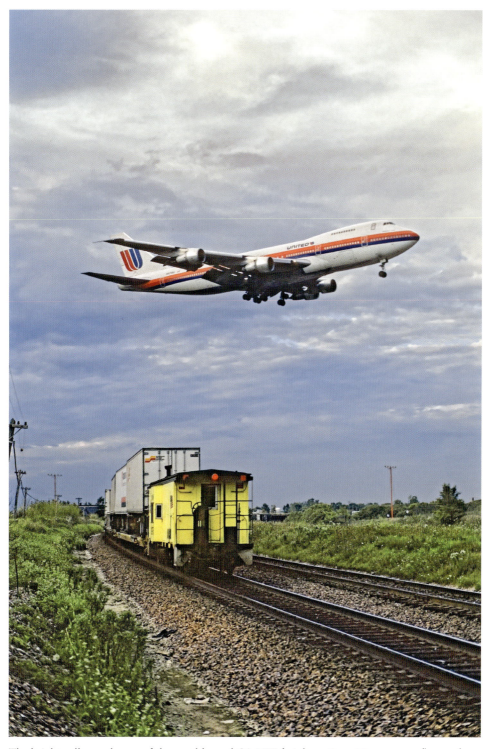

The bright yellow caboose of the northbound C&NW freight at Bryn Mawr gets a flyover from a United Airlines Boeing 747 landing at O'Hare International Airport in August 1984.

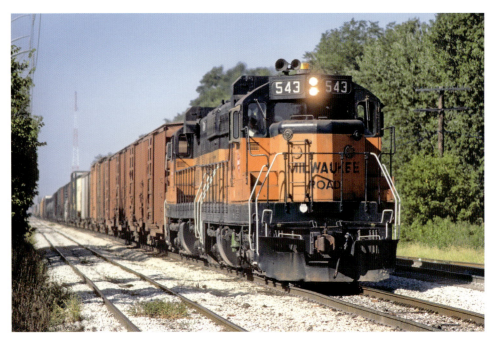

A pair of Milwaukee Road EMD SD10s power a train through La Grange Park as it approaches the Harding Avenue grade crossing while working southward on the Indiana Harbor Belt/B&OCT main line on 15 September 1985. These SD10 locomotives are rebuilt EMD SD7s, with the work done in the Milwaukee Road's own shop in Milwaukee, Wisconsin.

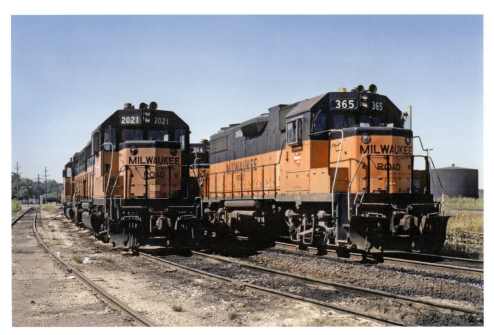

Milwaukee Road locomotives await new freight assignments at the locomotive facility at Bensenville on 15 September 1985. EMD GP38-2 No. 365 sits next to older sister EMD GP40 No. 2021.

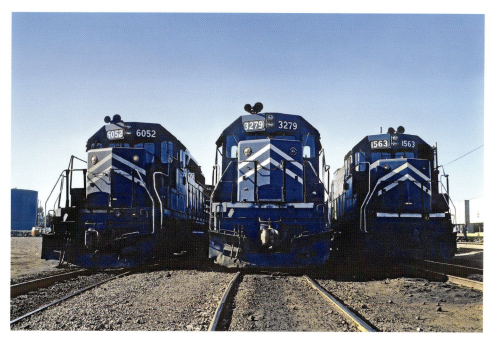

Missouri Pacific locomotives fill the locomotive storage tracks at Yard Center at Dolton on 15 September 1985. MP No. 6052 is a EMD SD40-2 purchased with dynamic brakes for coal service, while No. 3279 is of the same model without dynamics, and on the right is EMD GP15-1 No. 1563.

Santa Fe EMD GP30 No. 2755 leads a local freight west under Division Street overpass at Lockport on 12 October 1985. Lockport is just north of Joliet along the Chicago Sanitary & Ship Canal.

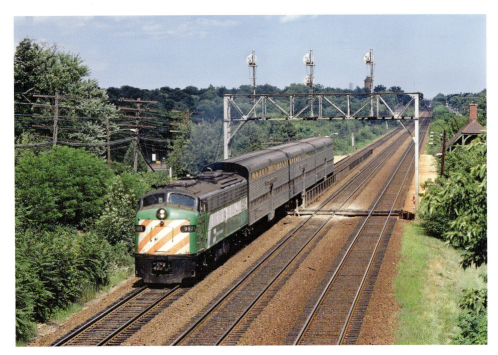

On Burlington Northern's triple-track main line from Chicago to Aurora another commuter train, or 'dinky' as they are called locally, heads west on Track 1 at Highlands on 2 August 1986.

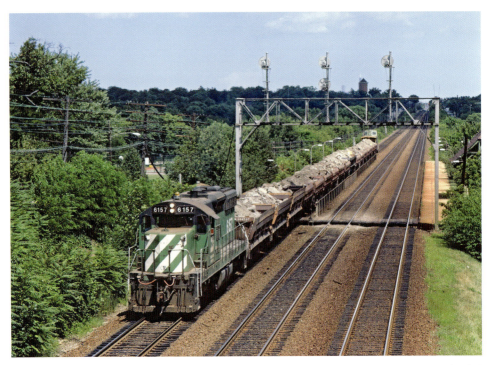

Led by venerable Burlington Northern EMD SD9 No. 6157, a westbound BN work train loaded with stone riprap rumbles through Highlands on 2 August 1986.

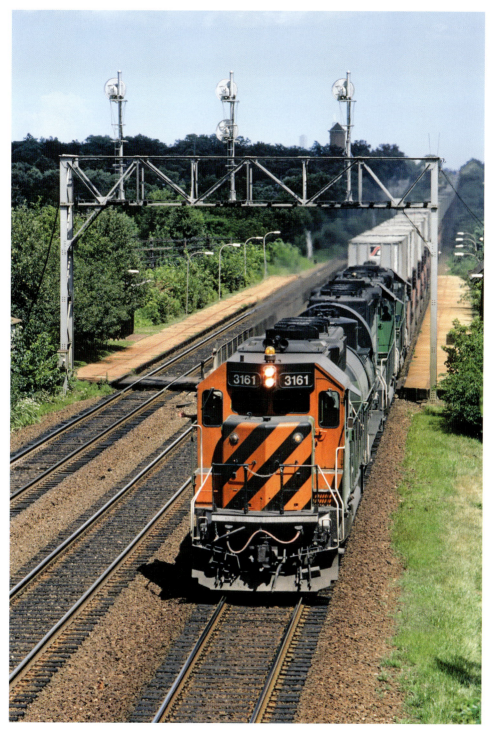

While getting a hearty wave from the engineer, three Burlington Northern EMD GP50s spliced by a fuel tender speed a westbound SeaLand double-stack train through Highlands on 2 August 1986. Tiger-stripe No. 3161 is the second to last EMD GP50 built.

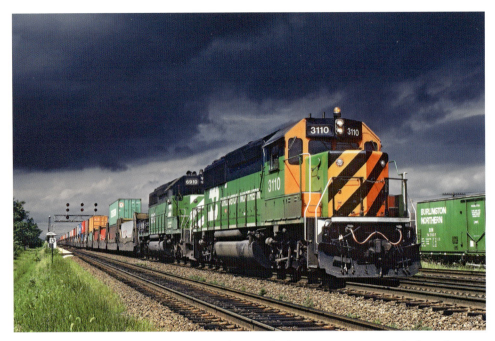

Chicagoland is still bathed in morning sun, but not for long as a storm moves in from the west. It's 10 August 1986 at Milepost 13 on Burlington Northern's triple track at Brookfield as an eastbound double-stack cruises by with a new EMD GP50 and a EMD SD40-2. BN No. 3110 is the railroad's first GP50 in the new tiger-stripe livery.

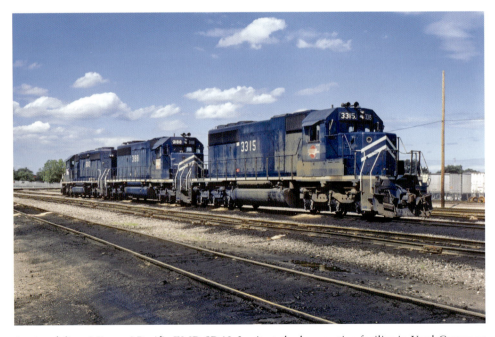

A trio of dirty Missouri Pacific EMD SD40-2s sit at the locomotive facility in Yard Center at Dolton on 10 August 1986. MP was merged into Union Pacific on 22 December 1982, but due to outstanding bonds, the full merger into the UP did not become official until 1 January 1997.

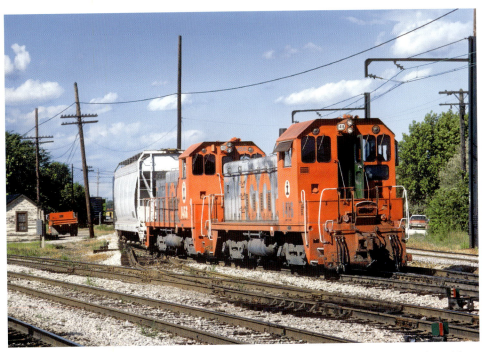

Illinois Central Gulf EMD SW14 Nos 1416 and 1456 switch cars at the south end of Markham Yard at Homewood on 10 August 1986. These SW14 switcher locomotives are rebuilt EMD locomotives, remanufactured in the railroad's shops at Paducah, Kentucky.

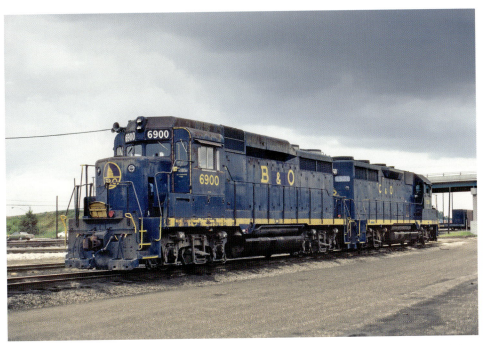

Baltimore & Ohio EMD GP30 No. 6900 and Chesapeake & Ohio EMD GP35 No. 3526 sit at Baltimore & Ohio Chicago Terminal's (B&OCT) Barr Yard in Riverdale on 10 August 1986.

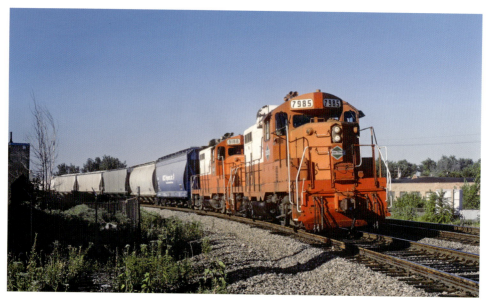

Still adorned in Illinois Central Gulf orange and white colors, Chicago Central & Pacific GP8 No. 7985 and GP10 No. 8188 lead a train around a curve at 55th Street Interlocking on the Belt Railway of Chicago, likely headed for the west end of BRC's sprawling Clearing Yard at Bedford Park.

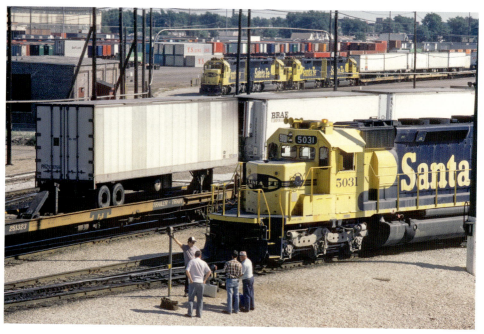

The crew for Santa Fe's hot 199 train stands in front of the yard tower at Corwith as they wait for an inbound train to pass on 30 August 1986. This busy Santa Fe terminal is where 199 begins its daily journey to the Bay area in Richmond, California. In a few minutes the train will clear and the crew will cross the tracks to the train seen in the background, which today is powered by a quartet of EMD GP50s.

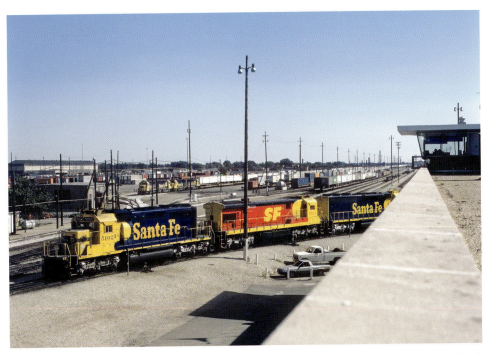

On 30 August 1986, we spent several hours photographing Santa Fe action as trains arrived, departed and switch crews rumbled past our location on the yard tower roof! In this view, a set of locomotives pass the foot of the tower on the way to an outbound train.

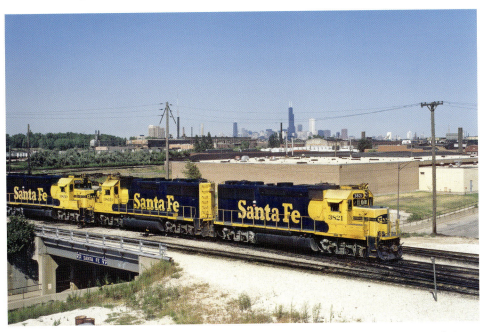

A set of Santa Fe EMD GP50s bring an eastbound intermodal train across the West 38th Street overpass into Corwith Yard on 30 August 1986. In this view from the roof of the yard tower, the Hancock Building and Sears Tower can be seen in downtown Chicago in the background.

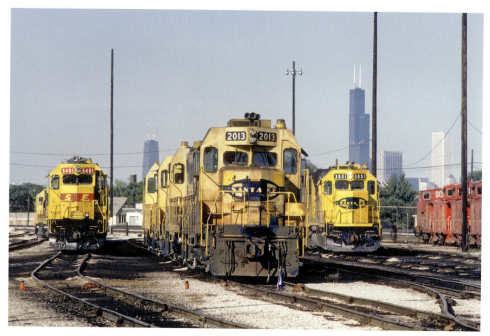

Various Santa Fe locomotives rest at Corwith Yard southwest of downtown Chicago on 30 August 1986. Left to right is EMD SD45 No. 5401 dressed in 'Kodachrome' SPSF merger paint, the 100-storey John Hancock Center, four EMD Geeps led by GP7u No. 2013, and finally the 108-storey Sears Tower looming over EMD GP40X No. 3801.

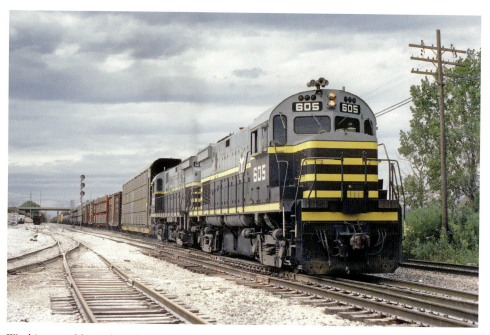

Working southbound on the Indiana Harbor Belt main line, a Belt Railway of Chicago freight is about to rattle across the Santa Fe main line at McCook on 6 September 1986. A pair of BRC Alco C424s, Nos 605 and 603, power the train past the dusty quarry tracks.

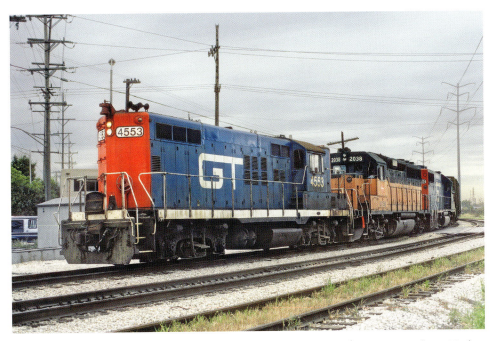

Grand Trunk Western EMD GP9 No. 4553 leads a northbound GTW train on Indiana Harbor Belt's main line through La Grange on 6 September 1986. The train is passing Sedgwick Park and is about to cross 47th Street grade crossing. Trailing No. 4553 is Milwaukee Road EMD GP40 No. 2038 and a GTW EMD GP38-2.

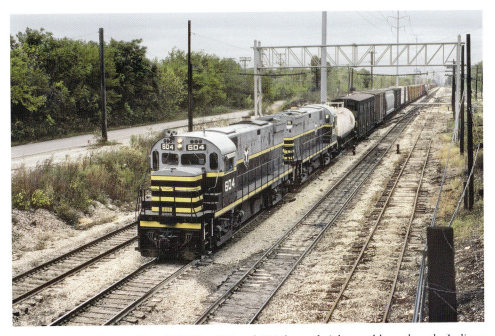

Belt Railway of Chicago Alco C424 Nos 604 and 605 drag a freight southbound on the Indiana Harbor Belt at La Grange on 12 October 1986. The train is about to duck under the Burlington Northern main line overpass.

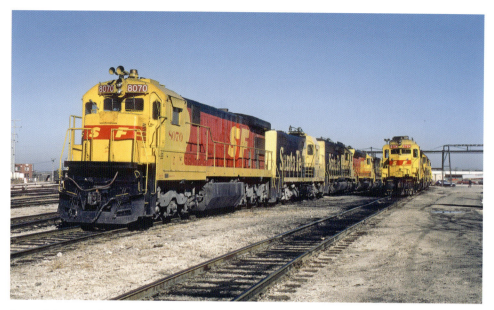

Several locomotives are lined up at Santa Fe's Corwith Yard locomotive facility on 22 November 1986. Three are painted in the mid-1980s merger scheme to be used with the proposed Southern Pacific/Santa Fe combination that never happened after being denied by the Interstate Commerce Commission. Santa Fe GE C30-7 No. 8070 and EMD GP30 No. 2724 show off their colorful yellow, red and black paint scheme that many dubbed 'Kodachrome', since the colors used resembled a Kodak Kodachrome film box.

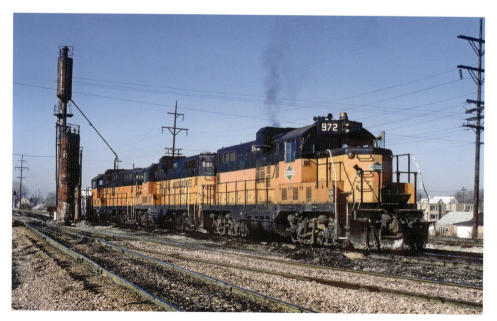

A trio of former Milwaukee Road EMD GP20s, now owned by Chicago Central & Pacific, depart the CC's locomotive facility at Hawthorne Yard at Cicero on 22 November 1986. These EMD GP9s are now 2,000 hp, rebuilt by Milwaukee and classified as GP20s. No. 972 is patched and re-lettered for CC, while No. 981 and 973 still retain Milwaukee Road lettering.

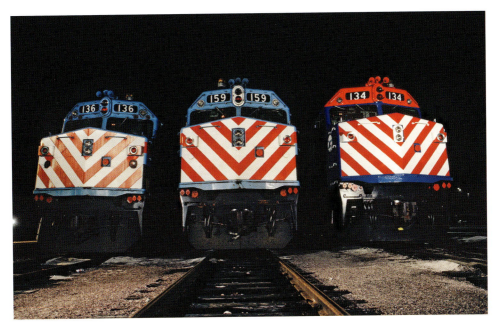

Ready for another trip to Chicago, Regional Transportation Authority (RTA) commuter trains wait out the night in the yard at Waukegan on 22 November 1986. RTA EMD F40PH Nos 136 and 159 are painted in RTA colors, while F40PH No. 134 is freshly painted in new Metra colors, not long after the formation of Metra (short for Metropolitan Rail) in 1985. Metra, simply put, is the Commuter Rail Division of the RTA.

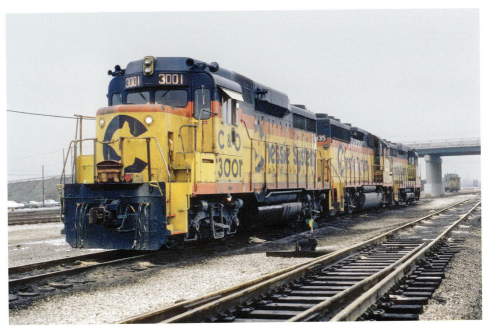

Chesapeake & Ohio EMD GP30 No. 3001, along with Baltimore & Ohio EMD GP40-2 No. 4335 and sister C&O GP30 No. 3021, all in Chessie System paint, sit at Barr Yard at Riverdale on a cold and foggy 23 November 1986.

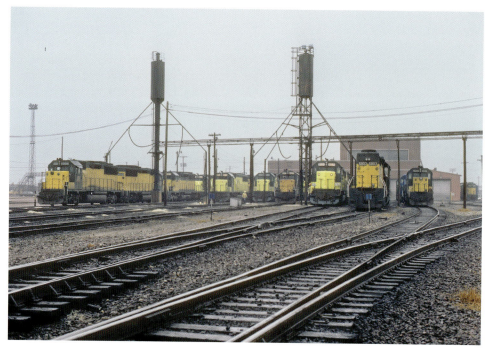

It's a dreary and damp day in the Chicago area on 23 November 1986, in a view of the Chicago & North Western's locomotive facility at Proviso Yard. Among all the EMD units there that day is a group of brand-new SD60s.

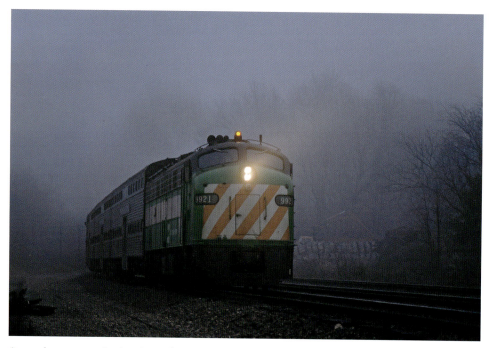

A raw, late autumn/early winter day in Chicagoland gives way to a foggy dusk on 29 November 1986, as a westbound Burlington Northern commuter train roars out of the gloom at Naperville.

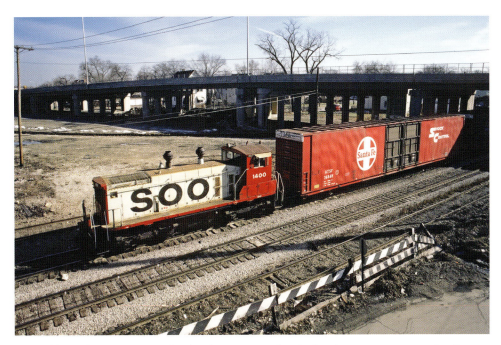

A northbound Soo Line transfer freight passes under Ogden Avenue overpass at La Grange on the afternoon of 7 February 1987. Soo EMD SW1500 No. 1400 is former Minneapolis, Northfield & Southern No. 36, and that bright red Santa Fe 86-foot auto parts boxcar sure dwarfs the locomotive!

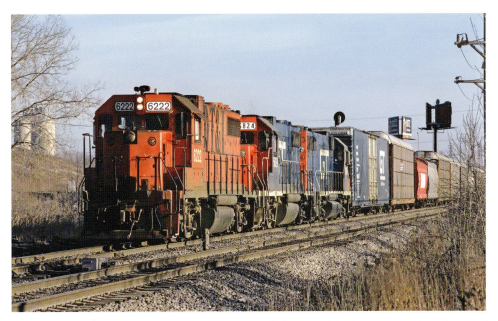

Grand Trunk Western EMD GP38-2 No. 6222, still decorated in the orange paint scheme of Detroit, Toledo & Ironton, is now working for GTW after a merger and leads one of their freight train on 7 February 1987. The train is operating northbound on Indiana Harbor Belt and is approaching the busy crossing of Santa Fe's main line at McCook.

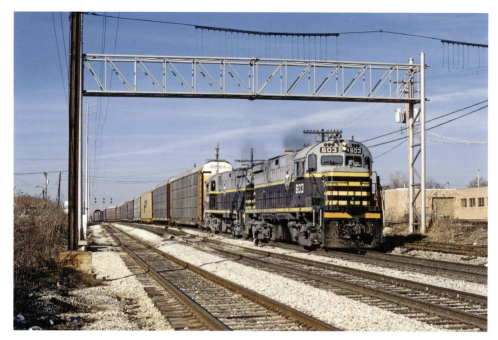

Belt Railway of Chicago Alco C424 Nos 603 and 604 cross over to Track 1 on the Indiana Harbor Belt main approaching the Burlington Northern overpass at La Grange, Illinois, on 7 February 1987. Note the still-in-place telltales, once used to warn railroad men riding the top of freight cars of low clearance ahead.

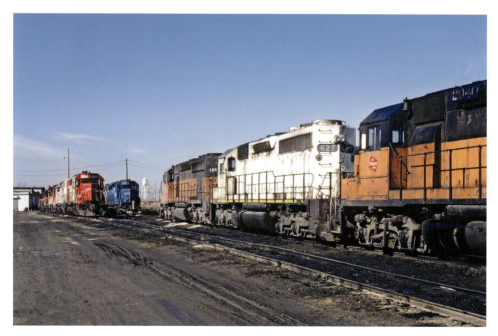

Soo Line, Milwaukee Road and Conrail EMD locomotives gather at Soo's former Milwaukee Bensenville Yard locomotive facility at Bensenville on 7 February 1987. Ghostly Soo Line SD40 No. 627 has been purchased second hand from Kansas City Southern.

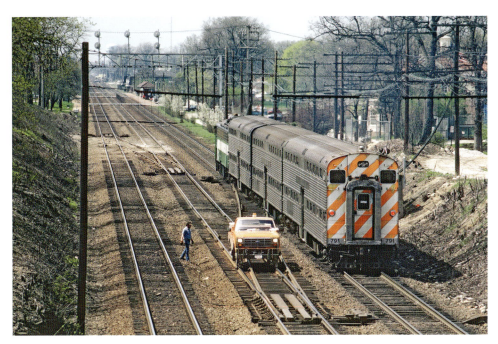

When inspecting Burlington Northern's busy First Subdivision of the Chicago Division, you still have to keep your wits about you, even on a weekend when there are fewer commuter trains. The track inspector has stopped his hi-rail truck on Main 2 at the crossovers at Highlands as a westbound BN 'dinky' commuter train roars by on Main 1 on 18 April 1987.

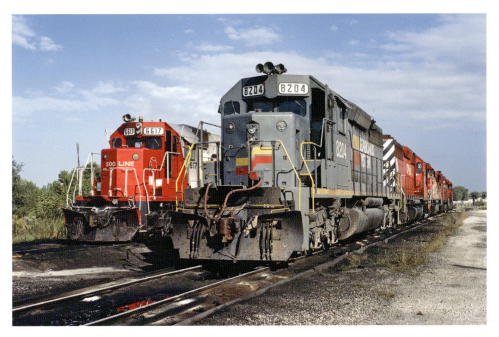

Seaboard System Railroad EMD SD40-2 No. 8204 rests with several Soo Line and Canadian Pacific SD40-2s at Soo's former Milwaukee Road locomotive facility at Bensenville Yard on 13 September 1987.

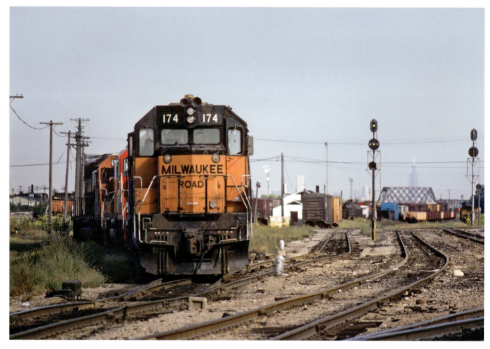

Milwaukee Road EMD SD40-2 No. 174 leads a locomotives consist back to their train at the west end of Bensenville Yard on 13 September 1987. Soo Line has owned the Milwaukee Road since 1 January 1986, and the once bankrupt property is still in pretty rough shape.

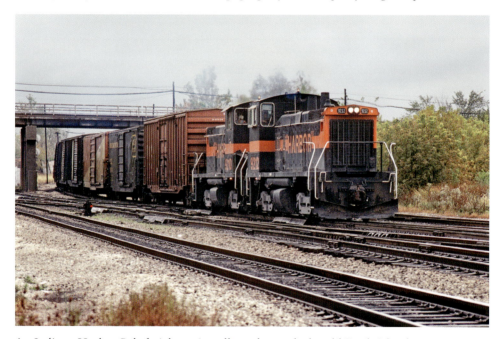

An Indiana Harbor Belt freight train rolls underneath the old Rock Island overpass, now owned and run by Metra and used by Iowa Interstate Railroad, at Blue Island on a rainy 10 October 1987.

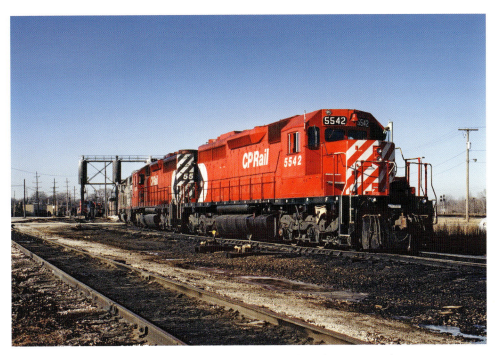

A pair of CP Rail (Canadian Pacific) EMD SD40s take a breather among other Soo Line power at the former Milwaukee Road Bensenville Yard locomotive facility on 5 December 1987.

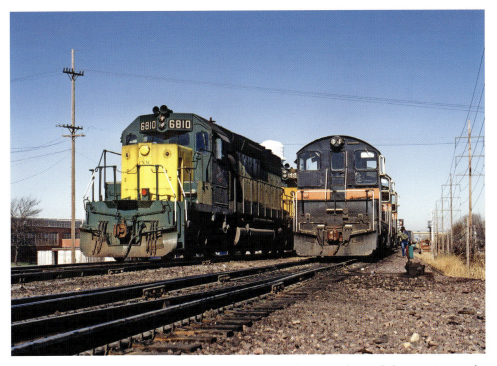

A Chicago & North Western coal train meets some Indiana Harbor Belt locomotives at the north end of C&NW's Proviso Yard near Grand Avenue in Northlake on 5 December 1987.

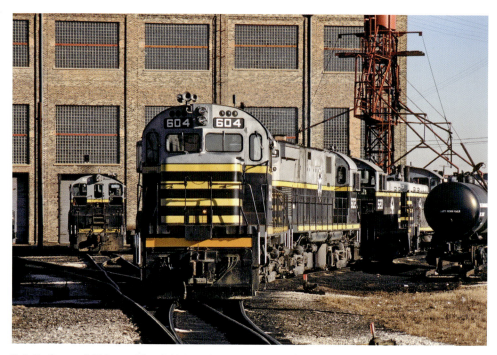

Belt Railway of Chicago Alco C424s and EMD SW9s and SW1200s congregate on the west side of the railroad's locomotive shop at Clearing Yard in Bedford Park on 5 December 1987.

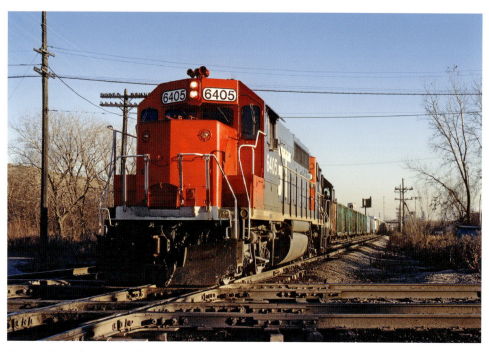

A Grand Trunk Western freight heads northbound through McCook on the afternoon of 5 December 1987. GTW No. 6405 is a former Detroit, Toledo & Ironton Railroad EMD GP38, joining the GTW locomotive roster with the acquisition of the DT&I in 1980.

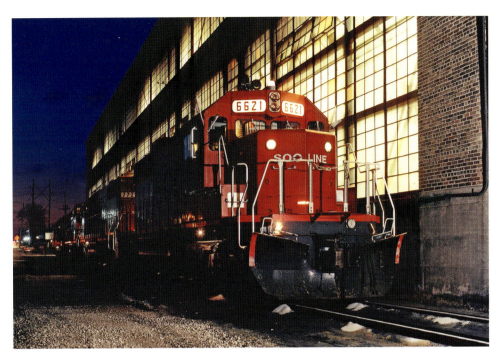

Several Soo Line and Milwaukee Road locomotives rest outside the illuminated engine house at the locomotive facility at Bensenville Yard on the night of 5 December 1987.

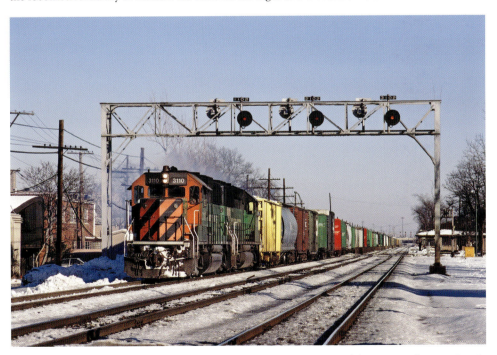

On a cold 2 January 1988, a Burlington Northern freight powered by a pair of EMD GP50s heads west through Riverside on the railroad's busy three-track main line between Chicago and Aurora.

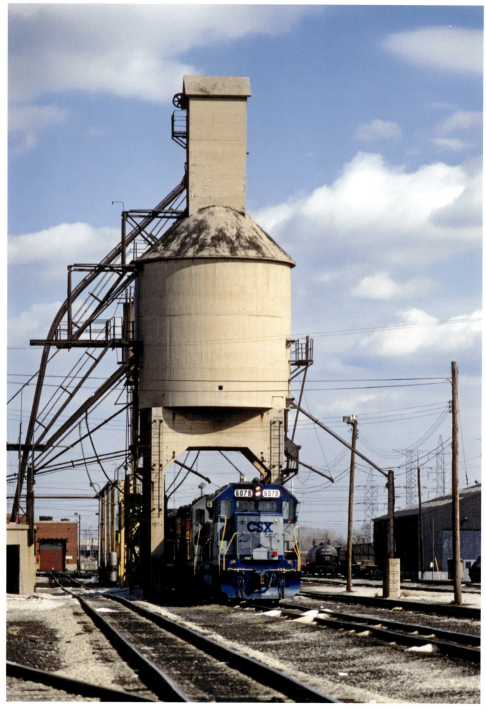

A string of CSX Transportation locomotives rest underneath a relic from a different age on the afternoon of 19 March 1988. This imposing concrete coaling tower that once loaded steam locomotive tenders with fuel now just looms over CSX EMD GP40-2 No. 6078 at the railroad's Barr Yard locomotive facility at Riverdale.

Railroads around Chicago 33

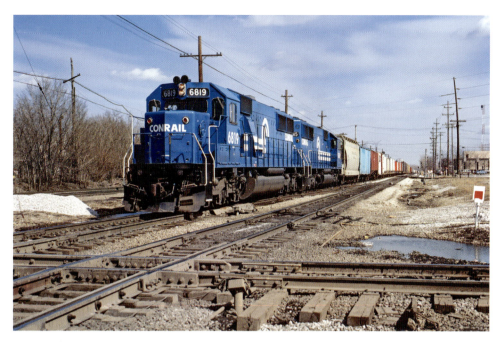

A pair of Conrail EMD SD50s power a westbound CR freight through the interlocking at Dolton on 9 January 1988. Trackage behind the locomotives is CSX (former B&O) and the train is about to cross the Missouri Pacific (former Chicago & Eastern Illinois) main line.

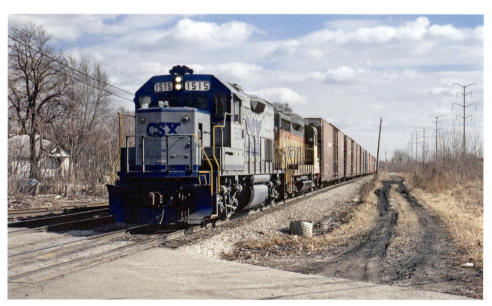

A CSX freight, led by EMD GP15T No. 1515, works out of Dolton at Riverdale on the afternoon of 19 March 1988. CSX Transportation initially was formed by the 1 November 1980 merger of Chessie System and Seaboard Coast Line Industries, with both of these holding companies to maintain their identities under the banner CSX Corporation. However, on 1 July 1986, the name Seaboard System Railroad was changed to CSX Transportation, and on 31 August 1987, CSX Transportation merged the Chesapeake & Ohio Railway.

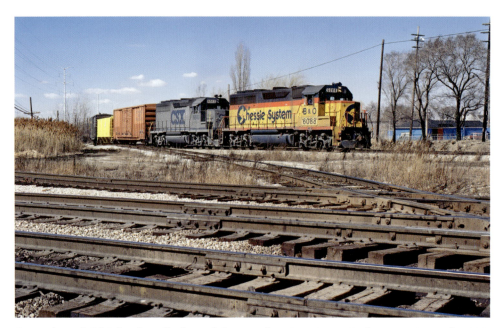

An eastbound CSX freight rolls through busy Dolton Junction at Dolton on 19 March 1988. The train is powered by a Baltimore & Ohio EMD GP40-2 that has recently renumbered into the CSX roster as No. 6088, and CSX EMD GP40 No. 6563, also a former B&O locomotive, now in one of CSX Transportation's early gray schemes.

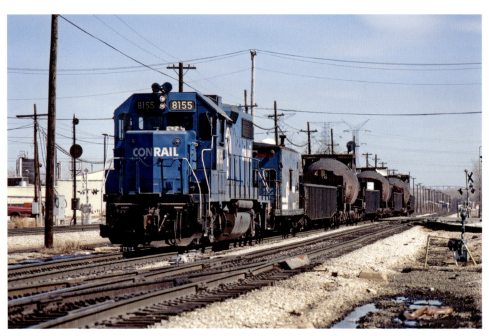

Conrail EMD GP38-2 No. 8155 powers a hot metal 'bottle train' approaching the busy junction at Dolton on 19 March 1988. These trains shipped molten metal from blast furnaces in East Chicago to a steel plant in nearby Riverdale, utilizing a short section of the former Pennsylvania Railroad's Panhandle line out of Dolton Junction.

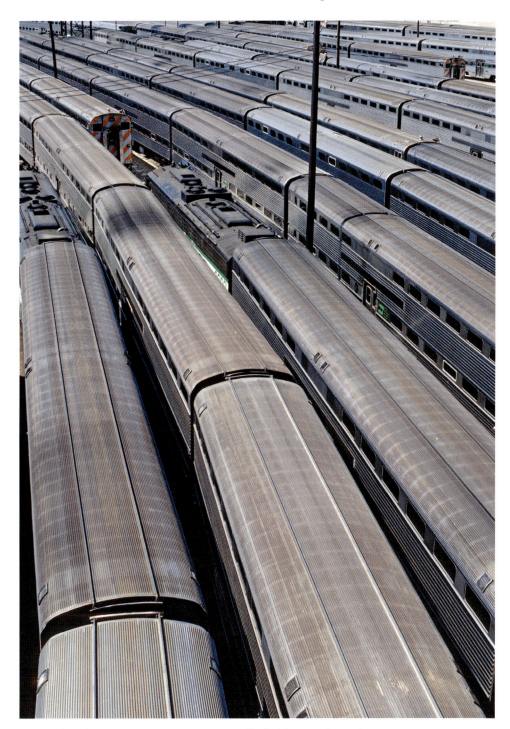

On weekends, commuter trains are generally held in yards at the westernmost towns on the routes so they are staged and ready to go back to Chicago come Monday morning. On 16 April 1988, a throng of Burlington Northern 'dinky' bi-level commuter trains lay over in a crowded Hill Yard at Aurora.

Two Burlington Northern EMD E9s sit in the BN Hill Yard at Aurora waiting for the call to duty hauling trains to Union Station in Chicago on a sunny 16 April 1988.

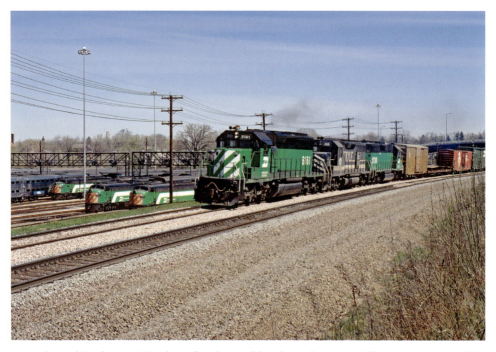

A westbound Burlington Northern freight rumbles through Aurora, Illinois, and passes BN/Metra commuter trains laying over in Hill Yard on Saturday 16 April 1988. The second unit on the freight is leased Kyle Railroad EMD GP40 No. 3116.

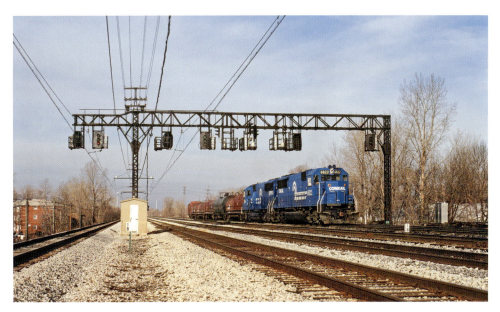

A pair of Conrail EMD SD50s power CR's Elkhart, Indiana, to Illinois Central's Markham Yard (ELIC) freight onto the IC at Milepost 18 in Riverdale on 3 December 1988. The two tracks on the left with overhead catenary wire are utilized by Metra Highliner-equipped electric commuter trains. Metra bought the Illinois Central Gulf's electrified commuter line in 1987 and started operating it directly as the Metra Electric Line.

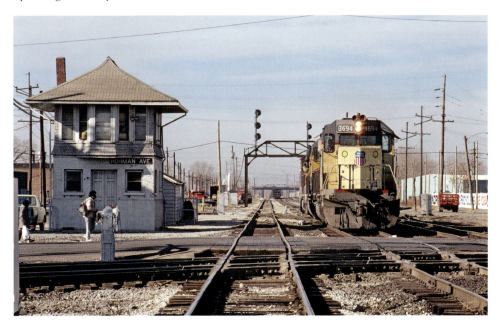

A trio of Union Pacific locomotives have just cut off their coal train in the background and have crossed the state line between Illinois and Indiana, and are now passing the tower at Holman Avenue in Hammond on 3 December 1988. The power and train is on Indiana Harbor Belt trackage, and lead UP EMD SD40-2 No. 3694 is about to cross Holman Avenue and the Norfolk Southern crossing.

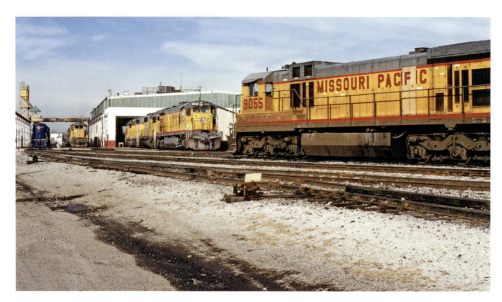

Union Pacific and Missouri Pacific locomotives are gathered at Yard Center at Dolton on 3 December 1988. MP was merged into UP on 22 December 1982, and initially it was to remain separate in name and image. But a year later, the 'image' part disappeared when Jenks blue colors began being covered with Armour yellow. GE C36-7 No. 9055 was delivered new in yellow, but the Missouri Pacific name was still used. Eventually, UP replaced 'Missouri' with 'Union' on the locomotive sides too, even though MP didn't officially disappear into the UP until 1 January 1997.

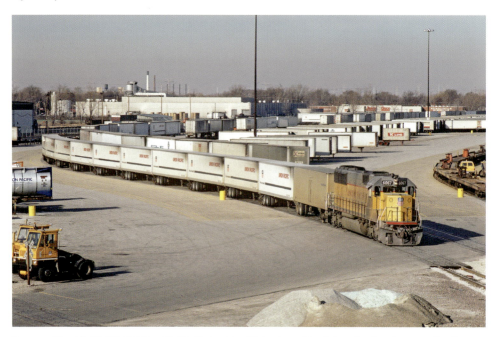

Powered by EMD SD60 No. 6067, Union Pacific's short-lived Roadrailer departs the former Missouri Pacific Dolton intermodal yard on its trip from Chicago to Dallas, Texas, on 3 December 1988.

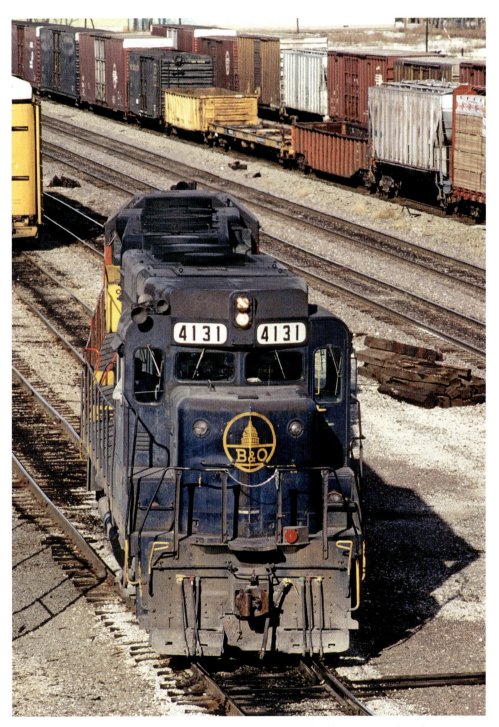

EMD GP30 No. 4131 still looks like a Baltimore and Ohio locomotive, but the new CSX Transportation road number replacing B&O No. 6960 reveals a new life in a much bigger system. CSXT No. 4131 has just cut off of a transfer freight at Yard Center at Dolton on 3 December 1988.

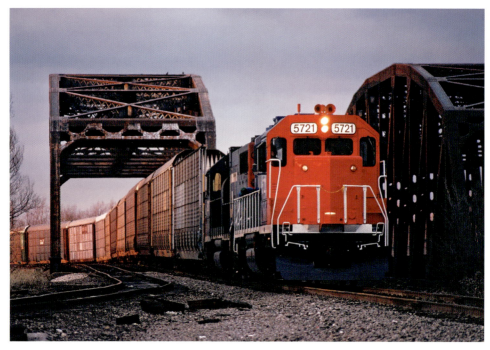

The last sunlight of 3 December 1988 lights up the autoracks on a Grand Trunk Western freight, led by freshly painted GTW EMD GP38-2 No. 5721, at Blue Island. The eastbound train is crossing one of the truss bridges over the Little Calumet River.

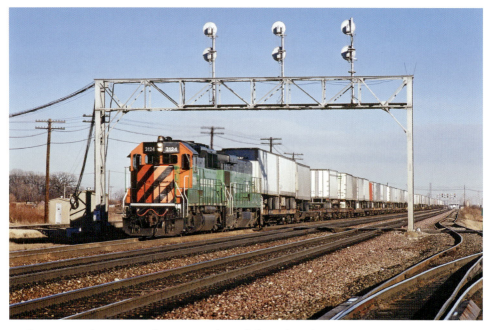

Burlington Northern train 3 hurries westbound through Eola on a sunny 23 December 1988. Tiger-stripe BN EMD GP50 No. 3124 and a cabless GE B30-7AB unit power the Seattle-bound piggyback train.

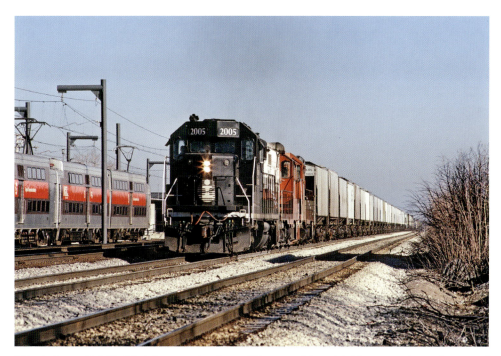

Illinois Central's SCMI freight operating from Chicago to Memphis, Tennessee, is passing one of Metra Highliner's electric commuter trains at University Park at Park Forest on 21 January 1989.

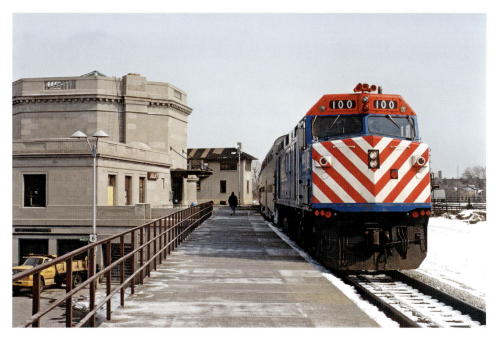

Sitting on the old Rock Island main line at Joliet Union station is a Metra bi-level commuter train that is about to depart for Chicago on 22 February 1989. The station, built in 1912, once served the passenger trains of Santa Fe, Rock Island and the Alton Railroad (later, Gulf, Mobile & Ohio).

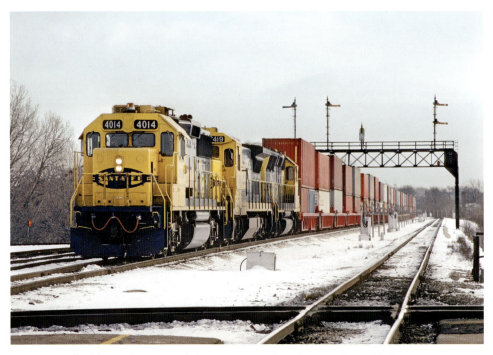

A Santa Fe double-stack intermodal train approaches the crossing with Iowa Interstate at Joliet Union station on 22 February 1989. Leading the eastbound train is Santa Fe EMD GP60 No. 4014, along with a GE B40-8 and an EMD GP40X.

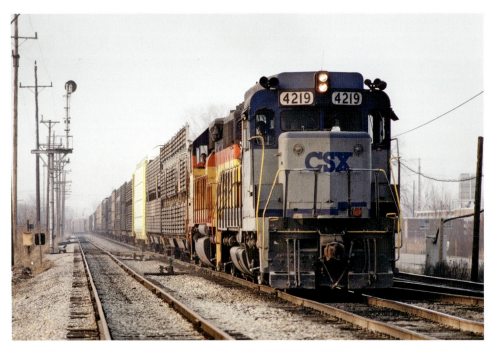

A CSX Transportation transfer freight, led by EMD GP30 No. 4219, makes its way south on the IHB/B&OCT main through Bridgeview on a gray 11 March 1989.

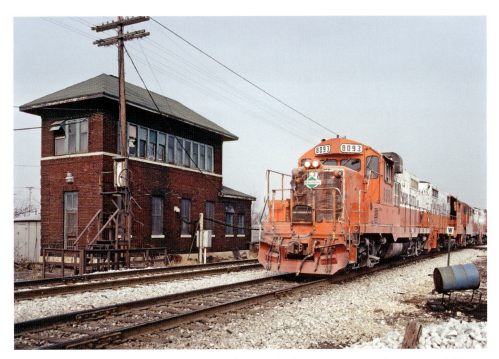

On 11 March 1989, a set of Chicago Central & Pacific locomotives rumble by Corwith Tower. This tower protected the Illinois Central (formerly ICG/GM&O) with Santa Fe tracks into Corwith Yard, and the former Illinois Northern crossing.

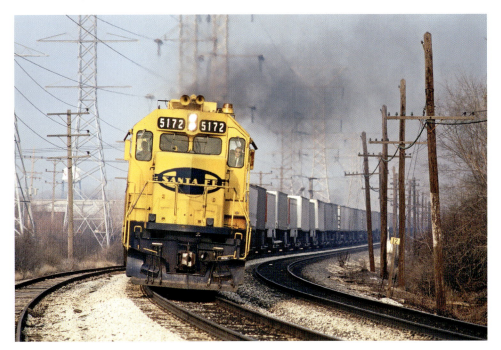

Santa Fe's 199 train operating from Chicago to Richmond, California, begins its journey on 11 March 1989, as it roars around the curve past Milepost 12 at McCook.

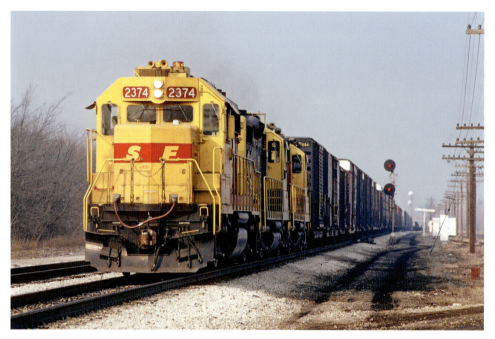

Willow Springs almost looks rural in this view of a Santa Fe freight heading west on 11 March 1989. Later, 186 acres of this location will be developed into an important intermodal yard, with United Parcel Service (UPS) also constructing a massive Chicago hub here, fully utilizing the yard.

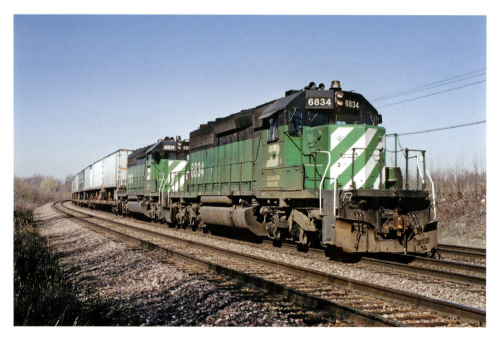

Burlington Northern train 50 rolls through the curve at Naperville at 9.02 a.m. on 15 April 1989. A pair of long, sweeping curves through Naperville on the busy Chicago to Aurora three-track main line was always an attraction for photographers.

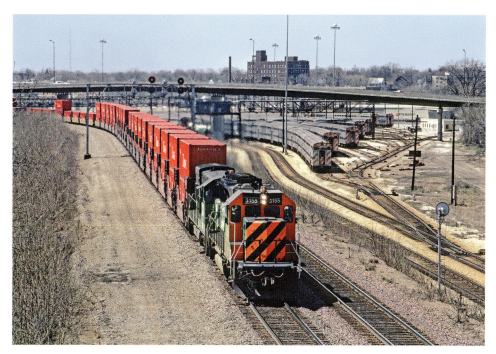

Burlington Northern train 4, with bright red K-Line container traffic up front, passes Hill Yard, where BN's commuter trains lay over at Aurora, on 15 April 1989.

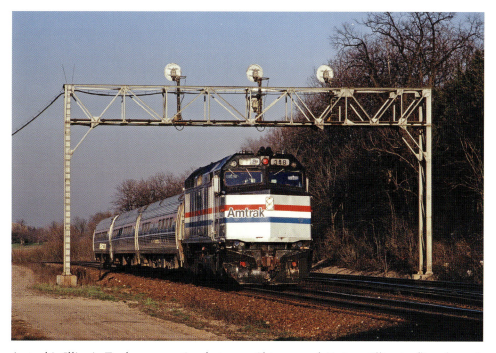

Amtrak's Illinois Zephyr, operating between Chicago and Quincy, Illinois, flies through Naperville at 6.05 p.m. on 15 April 1989. The train of three Amfleet cars is pulled by EMD F40PH No. 348.

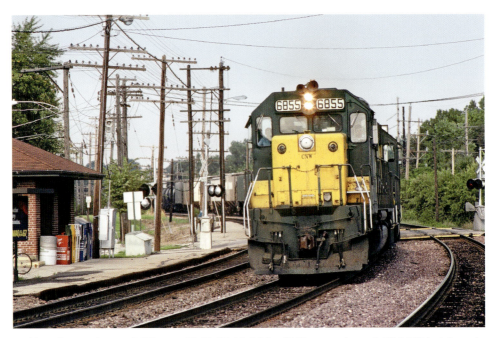

Led by Chicago & North Western EMD SD40-2 No. 6855, a westbound C&NW freight train curves past College Avenue between Glen Ellyn and Wheaton on 17 September 1989.

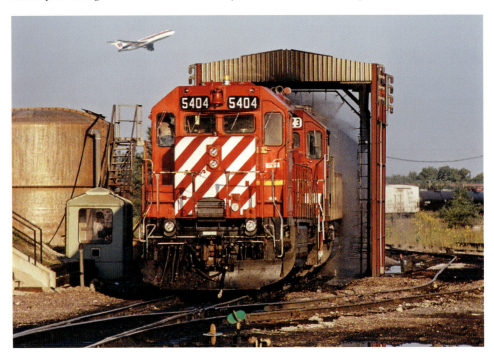

Getting a late bath on 17 September 1989, CP Rail EMD SD40 No. 5404 and a Soo Line SD40-2 are run through the wash building at Soo Line's former Milwaukee Road Bensenville Yard locomotive facility. Located near busy O'Hare International Airport, a United Airlines flight takes off in the background.

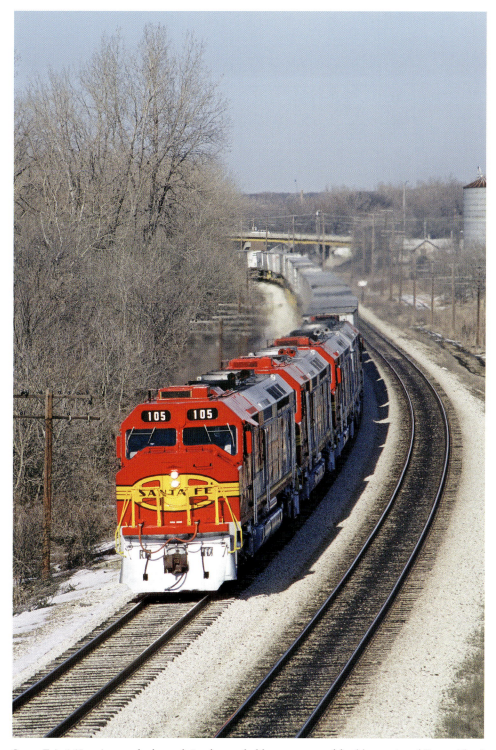

Santa Fe's 165 train speeds through Lockport, led by a quartet of freshly repainted 'Super Fleet' EMD FP45 cowl locomotives resplendent in warbonnet colors on 25 February 1990.

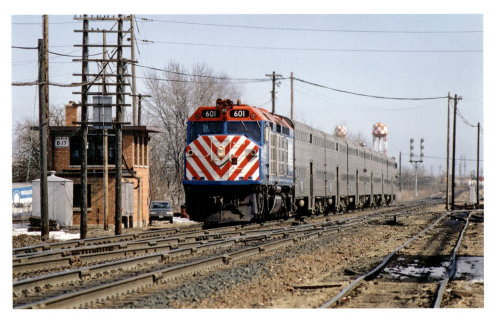

Metra EMD F40C No. 601 leads a westbound commuter train past Tower B17 at Bensenville on 3 March 1990. Similar looking to Amtrak's EMD SDP40F, the F40C has unique corrugated side panels and is built on a standard SD40-2 platform. Bought for commuter service on Milwaukee Road lines out of Chicago, a total of fifteen 3,200 hp F40Cs were built by EMD. The first thirteen units were bought by and lettered for North West Suburban Mass Transit District, while the remaining two were lettered for North Suburban Mass Transit District. All spent all their lives working the lines west to Elgin and Fox Lake, eventually working under the Chicagoland commuter authority Metra.

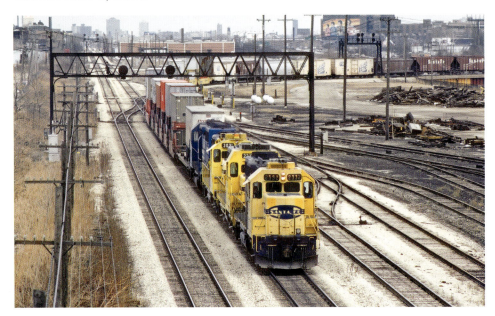

Santa Fe's 103 train, a freight operating from Chicago to Kansas City, departs Corwith Yard and begins its trip west as it approaches Pulaski Road overpass on 4 March 1990.

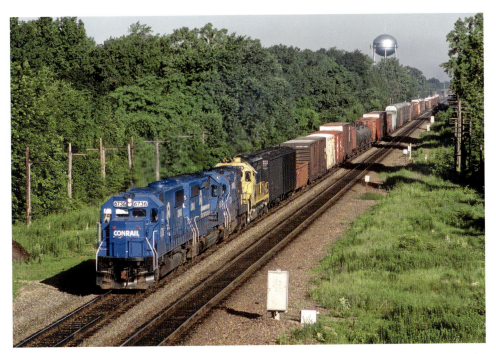

Conrail's SFEL4 freight off the Santa Fe makes a beeline through Chesterton, Indiana, over the railroad's busy Chicago to Elkhart Yard main line on the bright morning of 24 June 1990.

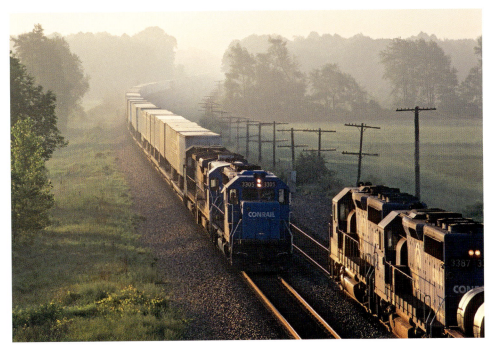

At 6.06 a.m. during a humid and hazy dawn on 1 July 1990, two Conrail trains meet at speed at Chesterton, Indiana. The westbound CR TV487 intermodal train meets an eastbound steel coil unit train on the busy former New York Central double-track main line.

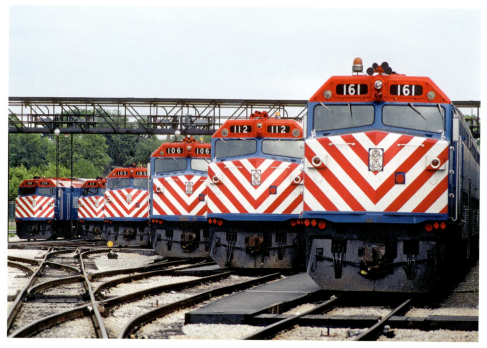

Metra EMD F40PH locomotives and their bi-level commuter trains wait out another weekend at Joliet on 2 September 1990. These trains serve Metra's former Rock Island route from La Salle Street station to Joliet.

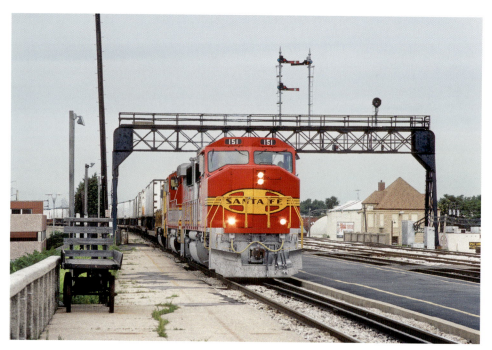

Santa Fe's 165 train speeds through Joliet on 2 September 1990. The westbound intermodal is led by a new GP60M No. 151 in Super Fleet warbonnet colors, built by EMD in August 1990.

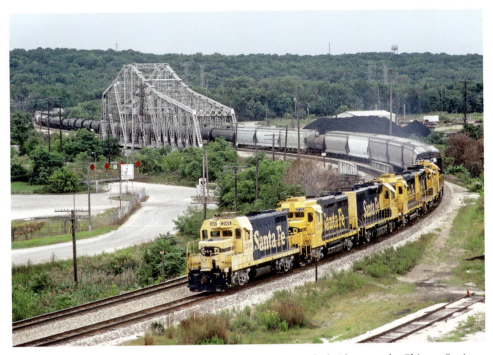

A westbound Santa Fe freight rumbles into Lemont, crossing the bridge over the Chicago Sanitary and Ship Canal, on 2 September 1990. Powering the train are six EMDs, led by venerable EMD GP7u No. 2149, mated to a GP30, a GP39-2, another GP30, a GP20 and another GP7u.

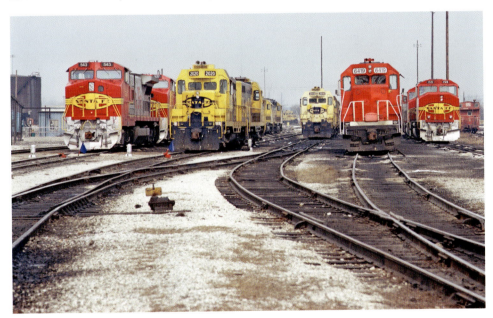

An assortment of Santa Fe locomotives, as well as a set of Grand Trunk Western power off a transfer freight, gather at Santa Fe's Corwith Yard on 9 February 1991. From left to right: GE B40-8W; EMD GP7r No. 2020; another GP7r, No. 2016; GTW EMD GP40-2 6419; and EMD GP60M No. 159.

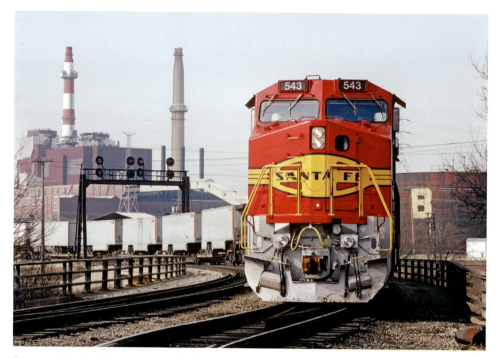

Santa Fe's 991 train curves over the bridge spanning Interstate 55 (Stevenson Highway) and is about to cross the Illinois Central and enter Corwith Yard on 9 February 1991. Not much in this photo is the same today – the signal bridge is replaced, the power plant is gone, Santa Fe is long gone, and No. 543 is now BNSF orange.

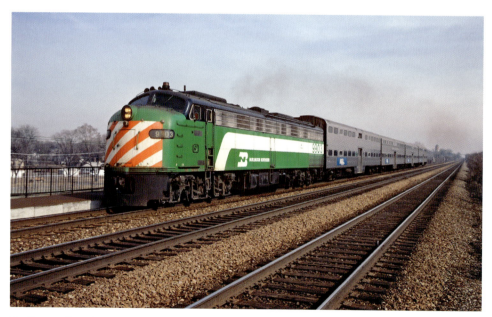

Burlington Northern EMD E9 No. 9903 pulls a four-car commuter train into the station stop of Highlands on 9 February 1991. Highlands ended up being a great place to observe BN action with a nearby overhead bridge and a nice park to relax in – but not so much in February.

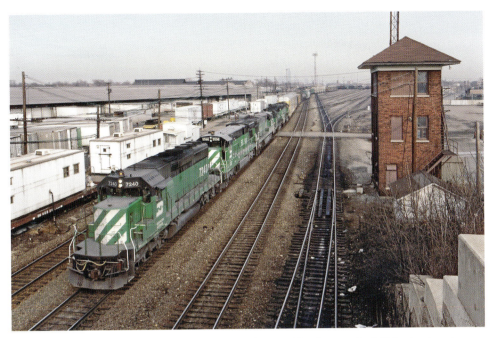

Powered by five Cascade green locomotives, Burlington Northern train 161 begins its trip west as it departs Cicero passing the tower on the far west end of Clyde Yard approaching LaVergne on the afternoon of 9 February 1991.

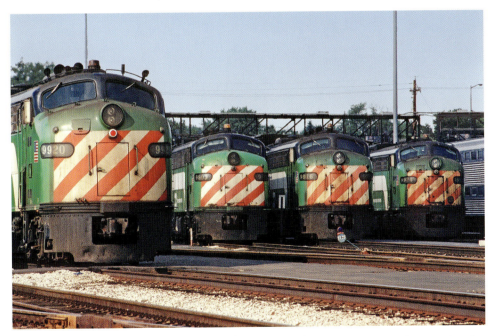

Burlington Northern EMD E9 cab units line up on Metra commuter trains pausing for the weekend at Hill Yard in Aurora on the afternoon of 8 June 1991. Twenty-five of these locomotives, rebuilt by Morrison-Knudsen in two groups in 1973 and 1976, served the BN commuter line well, but by this time, the end was near.

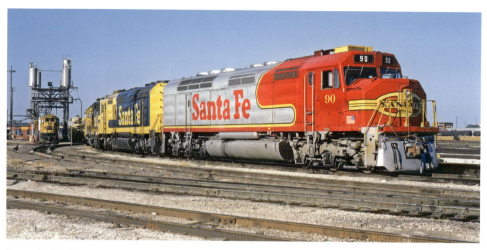

Santa Fe EMD FP45 No. 90 rests at the Corwith Yard locomotive facility on 1 September 1991. These cowl locomotives were built at the request of Santa Fe, who wanted to replace old F units used on its passenger trains, and desired a locomotive at least somewhat 'streamlined'. Originally built as No. 100 in December 1967, it quickly went from passenger to freight service with the coming of Amtrak in 1971, and soon don Santa Fe freight locomotive colors and number series. With Super Fleet warbonnet colors returning to the Santa Fe in 1989, the burly engine was again cloaked in shiny red and silver paint, and numbered 100. With the arrival of new EMD GP60Ms in the 100 series in 1990, it was briefly again renumbered 5990 and at long last No. 90. The historic locomotive was finally retired at the hands of BNSF on 14 January 1999, and donated to the Oklahoma Railroad Museum in 2000.

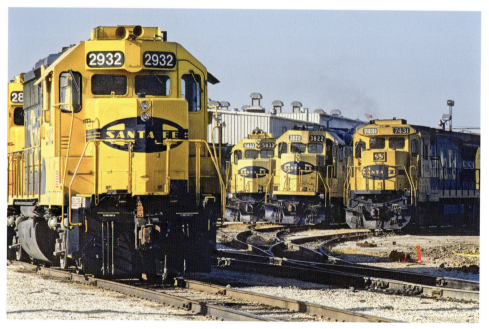

Locomotives line the tracks at Santa Fe's Corwith Yard locomotive facility on 1 September 1991. Santa Fe EMD GP35r No. 2932 stands front and center (okay, off to the left a bit), while in the background EMD SD45-2 No. 5833, EMD GP50 No. 3822 and GE B40-8 No. 7431 gather behind.

The conductor on a CSX transfer freight out of C&NW's Proviso Yard looks back at his train rocking and rolling through the crossovers at Bellwood on 1 September 1991. The train is entering Indiana Harbor Belt/Baltimore & Ohio Chicago Terminal trackage at CP Hill.

Chicago & North Western EMD GP15-1 No. 4410 and EMD GP7 No. 4144 tug at a long string of coal gondolas out of the east end of Proviso Yard on 1 September 1991. The train is approaching the 25th Avenue grade crossing at Bellwood.

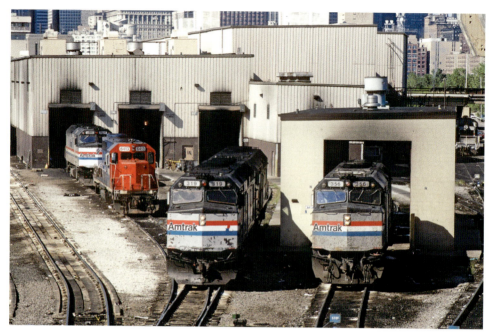

Amtrak's Chicago locomotive facility hosts Grand Trunk Western EMD GP40-2 No. 6413 amongst the usual plethora of National Railroad Passenger Corporation (better known as Amtrak) EMD F40PH locomotives on 1 September 1991.

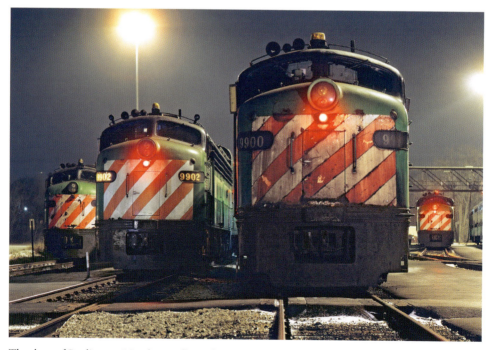

The days of Burlington Northern's fleet of EMD E9s in Chicago to Aurora commuter service are getting short as several of the battle-worn veterans rest in the yard at Aurora on the cold autumn night of 23 November 1991.

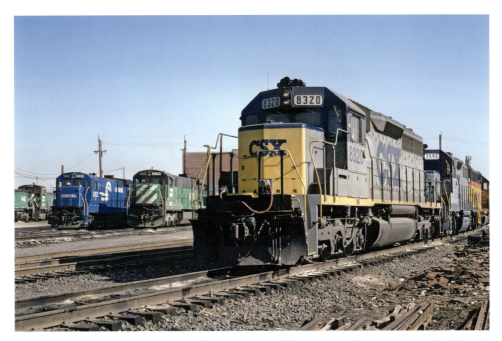

A trio of CSX Transportation EMD locomotives in three paint schemes pause at Burlington Northern's Clyde Yard locomotive facility in Cicero on 9 February 1992. Resting closer to the engine house in the background are Conrail GE B36-7 No. 5002 and BN GE C30-7 No. 5134.

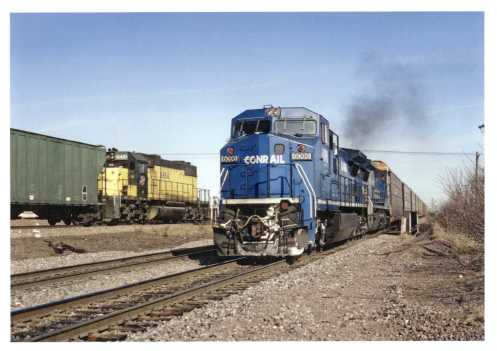

A train of autorack cars powered by Conrail locomotives, led by CR GE C40-8W No. 6098, approaches Chicago & North Western's Proviso Yard at Northlake on 9 February 1992. On the left, C&NW EMD SD38-2 No. 6654 switches cars.

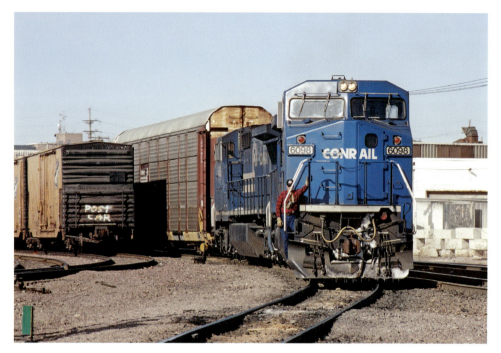

An autorack train arrives at Chicago & North Western's Proviso Yard on 9 February 1992. A pair of Conrail GE C40-8W locomotives provide motive power for the train.

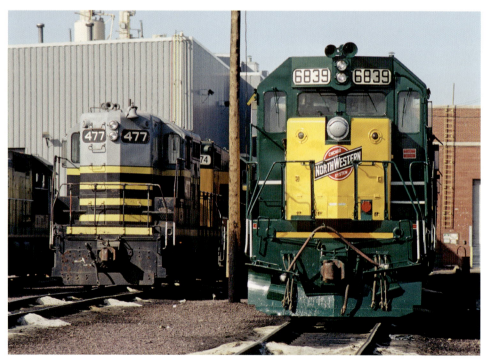

Chicago & North Western EMD SD40-2 No. 6839 and Belt Railway of Chicago EMD GP7 No. 477 sit in the morning sun at C&NW's Proviso Yard locomotive facility on 9 February 1992.

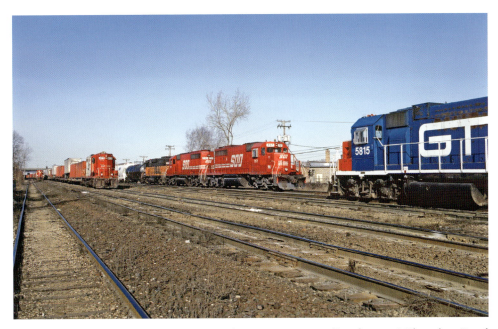

Busy times at Franklin Park. Just east of Soo Line's sprawling former Milwaukee Road Bensenville Yard, an eastbound Soo Line freight meets a westbound Grand Trunk Western train near Scott Street grade crossing in Franklin Park on 9 February 1992. On two of the tracks to the left, a pair of Soo Line EMD GP9s switch cuts of stacks and piggyback trailer flat cars for the railroad's Bensenville Intermodal Terminal.

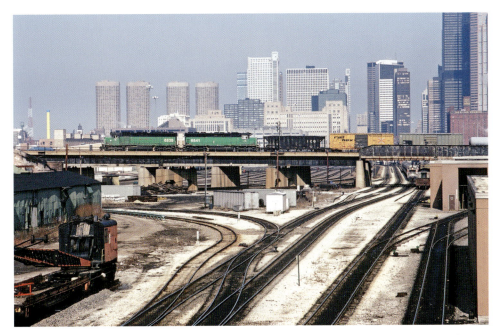

A westbound Wisconsin Central freight, powered by a pair of WC EMD SD45s still in former Burlington Northern Cascade green, is crossing the St Charles Air Line Bridge near Canal Street in Chicago on 22 February 1992.

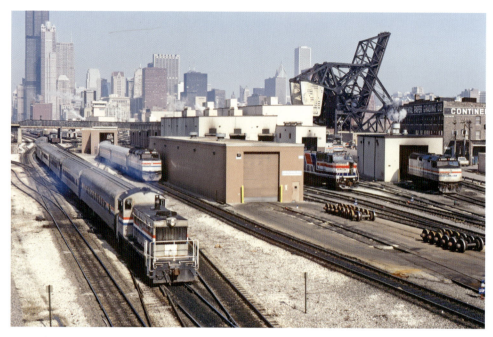

Amtrak EMD SW8 No. 749 switches some Heritage Fleet passenger cars on the tracks adjoining the railroad's Chicago locomotive facility in a view from the 18th Street overpass on 22 February 1992.

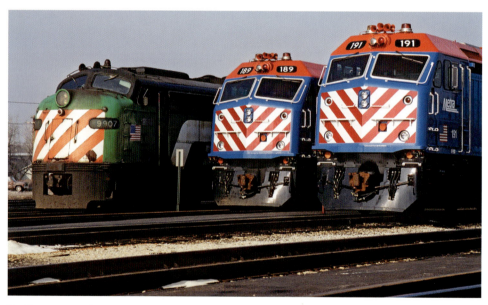

Burlington Northern EMD E9 No. 9907 sits alongside two of its replacements – Metra EMD F40PHM-2 Nos 189 and 191 – at Hill Yard in Aurora on 22 February 1992. Metra bought thirty of these 3,200 hp locomotives units in 1991–92. No different mechanically than a EMD F40PH-2, but the streamlined cab and built-out windows give them a distinctive profile. For some, the unique slanted windows and lack of a front nose gave the locomotives the informal nickname 'Winnebagos' after the popular line of similar-looking recreational vehicles.

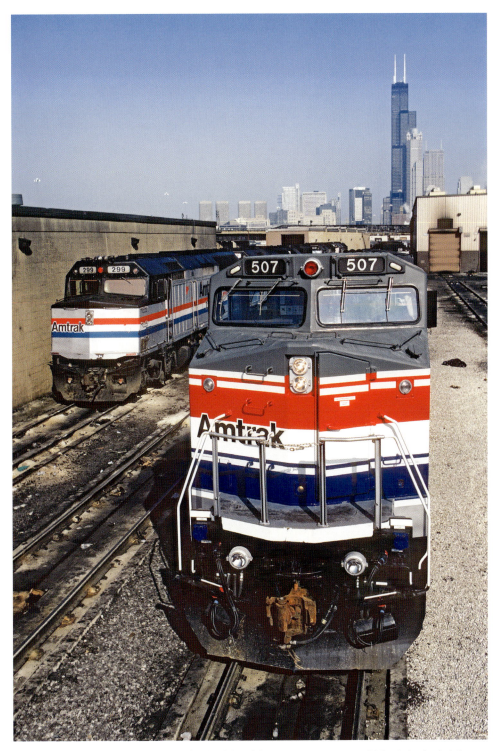

New Amtrak GE P32BH No. 507, flanked by older EMD F40PH No. 299, sit in the bright sun beneath a Chicago skyline on 22 February 1992.

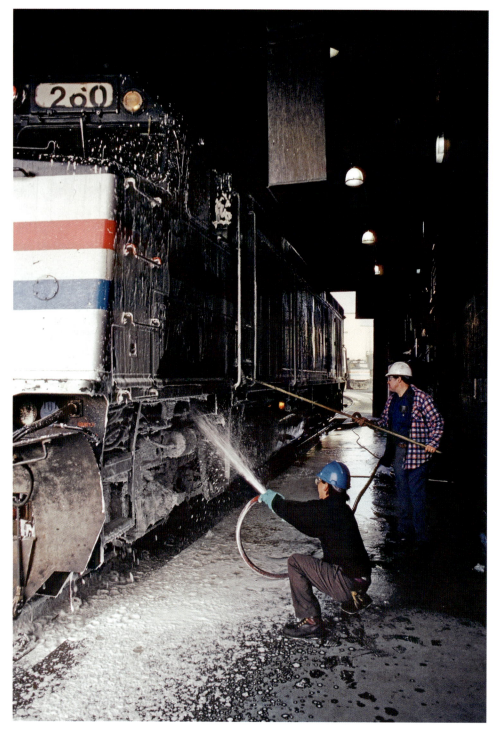

Clean locomotives hauling America's public passenger trains are not a bad idea, so Amtrak EMD F40PH No. 260 gets a foamy bath inside the wash building at Amtrak's locomotive facility in Chicago on 22 February 1992.

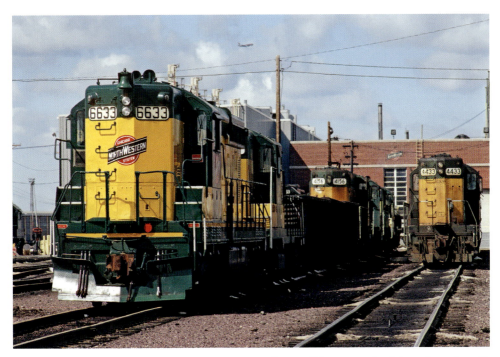

Chicago & North Western EMD SD18 No. 6633 shows off its new paint job at the railroad's Proviso Yard locomotive facility at Proviso on the morning of 15 March 1992. C&NW acquired a group of Southern Railway EMD SD24s and rebuilt them, reclassifying them as SD18s.

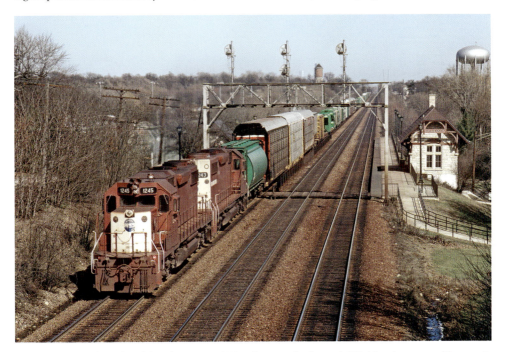

Burlington Northern local freight No. 11451 rolls smartly through Highlands powered by a pair of leased former Reserve Mining EMD SD38-2s on a sunny 15 March 1992.

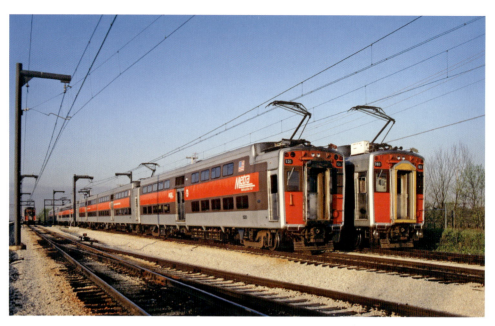

Bi-level Metra Highliner-equipped commuter trains sit at the end of the former Illinois Central electric main line out of Chicago at University Park on the morning of 9 May 1992. The Highliner is a bi-level multiple unit rail car, originally built for IC by St Louis Car Company in 1971, with additional cars later constructed by Bombardier.

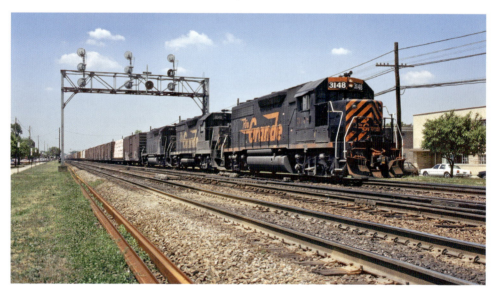

A Southern Pacific freight approaches its Chicago destination at LaVergne in Berwyn on Burlington Northern's busy Aurora to Chicago triple-track main line on 28 May 1992. Somewhat unusual, a trio of Rio Grande EMD locomotives power the eastbound train. Leading the way is a former Conrail GP40, now Rio Grande No. 3148 and painted black and orange, instead of Aspen gold. Trailing is Rio Grande's only GP35 decorated with the large billboard logo on the long hood, and third out is a dirty GP40 No. 3060 that still carries a small logo underneath the filthiness.

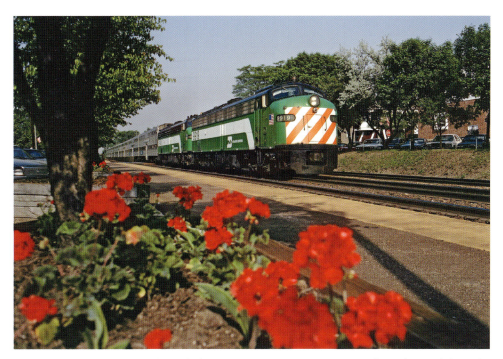

A rush hour Burlington Northern 'dinky' express commuter train cruises through Hinsdale on the center main on 28 May 1992. Geraniums are blooming in the planters alongside the platforms adding more color to the nice spring day, as the two BN EMD E9s roar west toward Aurora.

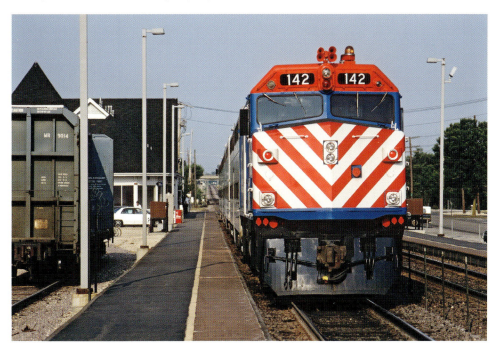

A Metra commuter train pauses at the station at Geneva on Chicago & North Western's west main line on the afternoon of 13 June 1992.

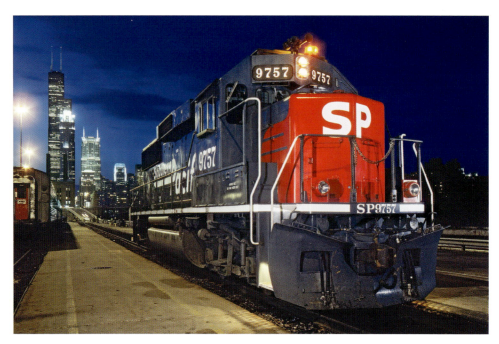

In the early 1990s, Southern Pacific finally made it to Chicago by acquiring the bankrupt Chicago, Missouri & Western's line from St Louis and through trackage rights via Burlington Northern. To advertise SP's entrance to railroading's Midwestern mecca, the railroad set up a publicity shot with clean EMD GP60 No. 9757 at Amtrak's 18th Street Yard on 17 July 1992.

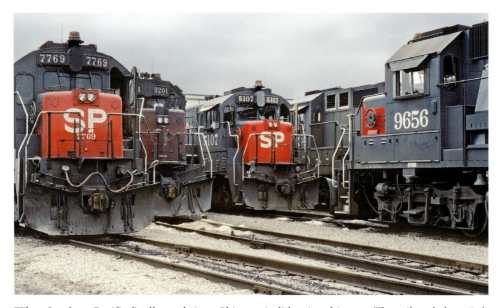

When Southern Pacific finally made it to Chicago, it did so in a big way. The railroad chose Belt Railway of Chicago as the area's rail facility to be utilized by the railroad, and in this scene, SP power gathers at BRC's Clearing Yard. Left to right: GE B36-7 No. 7769, EMD SD45T-2 No. 9201, GE B23-7 No. 5107, GE B39 No. 8034 and EMD GP60 No. 9656. A full (Clearing) house in the Windy City on 16 July 1992.

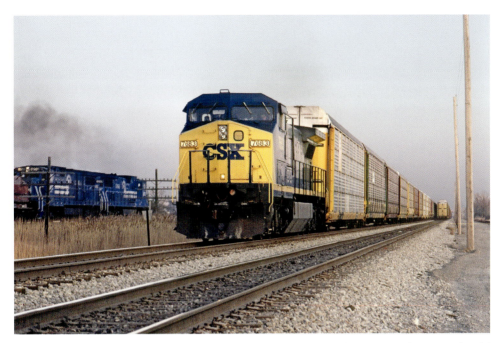

CSX GE C40-8W No. 7683 hauls a train of autoracks westbound at Gary, Indiana, on the old Baltimore & Ohio main line late in the day of 11 February 1995. Just to the north on the former New York Central main line is an eastbound Conrail train powered by a pair of GE C39-8 locomotives.

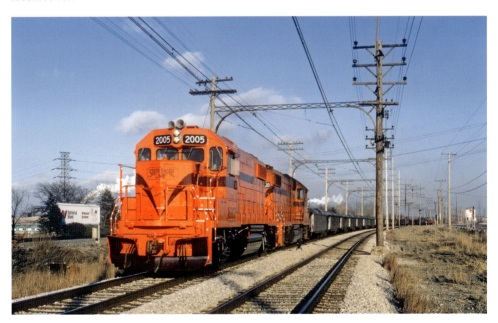

A westbound Chicago South Shore & South Bend Railroad freight, loaded mostly with heavy steel coils, is about to cross the grade crossing entrance to National Steel at Portage, Indiana, on the afternoon of 11 February 1995. The train is powered by a pair of bright traction orange CSS EMD GP38-2 locomotives.

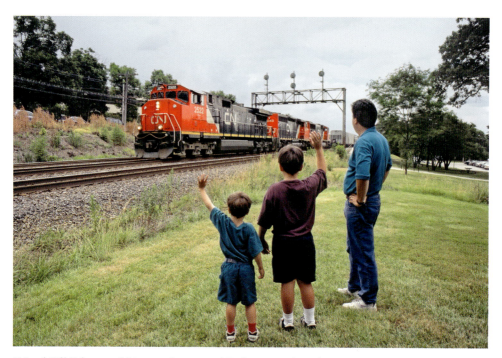

Friend Bill Edgar and his sons James and Robert watch and wave to a westbound Canadian National freight charging through Highlands on 15 July 1996.

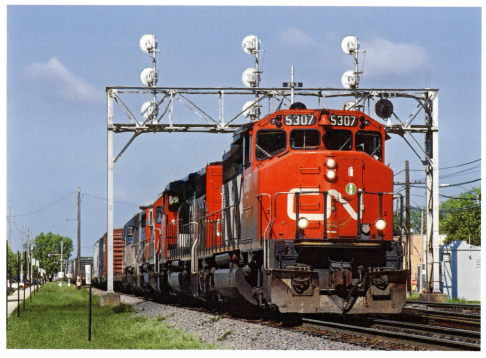

An eastbound Canadian National freight passes through LaVergne on Burlington Northern's busy three-track main line between Chicago and Aurora on 2 June 1996.

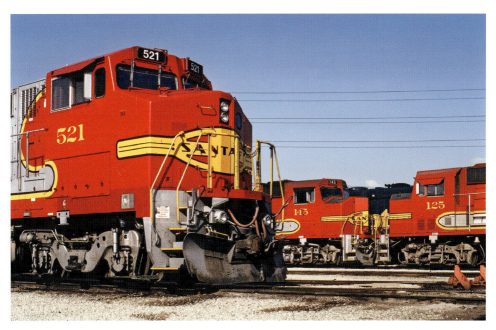

Super Fleet warbonnet Santa Fe locomotives are everywhere at the railroad's servicing facility at Corwith Yard on 2 June 1996. GE B40-8W No. 521 shares track space with EMD GP60M Nos 145 and 125. Even though the Santa Fe and Burlington Northern were merged the year before with the formation of a holding company on 22 September 1995, the operating railroads formally merged into the Burlington Northern & Santa Fe Railway on 31 December 1996, and scenes like this would soon become a rarity.

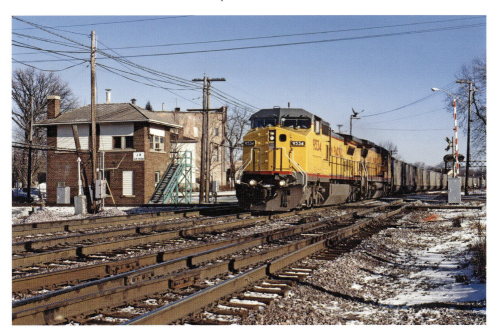

A westbound Union Pacific empty coal train crosses Washington Street grade crossing and clatters over the Elgin, Joliet & Eastern diamond at JB Tower in West Chicago on 20 December 1996.

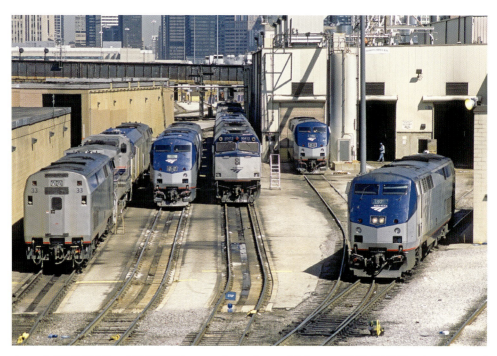

Amtrak GE P42DC and P32BWH locomotives, along with former EMD F40PH units converted to NPCU cab cars, rest outside Amtrak's Chicago Locomotive Service Building on 17 April 2009.

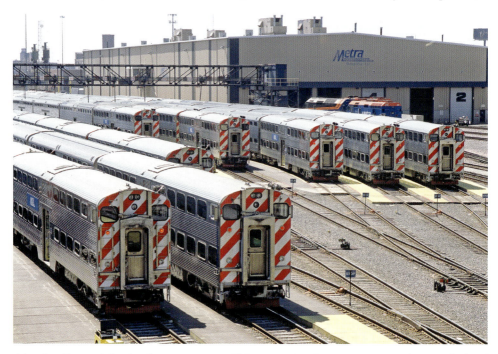

After hauling trainloads of commuters to Chicago Union Station, a group of Metra bi-level trains lay over at the railroad's 14th Street coach yard along Canal Street (since CB&Q days, nicknamed the Zephyr Pit) on 17 April 2009.

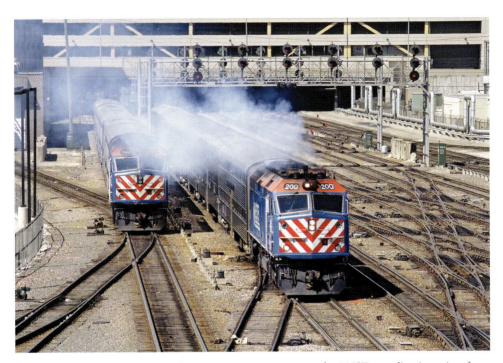

Coming and going with a pair of Metra commuter trains on the BNSF west line in a view from Roosevelt Road overpass on 17 April 2009. Metra EMD F40PHM-2 No. 200 has been idle for a while and blows out the carbon.

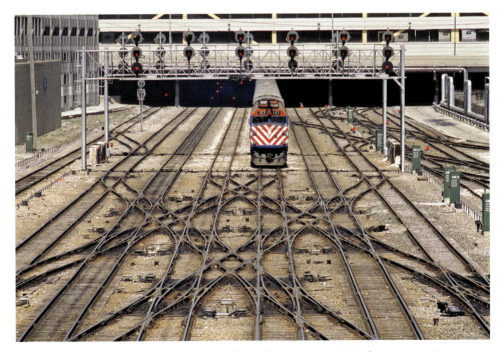

Led by Metra EMD F40PH No. 103, an outbound commuter train is about to negotiate a maze of trackage leading from Chicago Union Station on 17 April 2009.

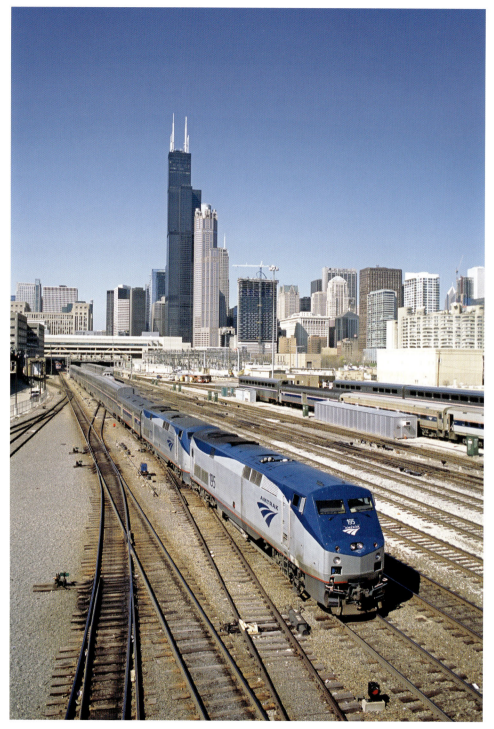

Amtrak's westbound Southwest Chief departs Chicago for Los Angeles, California, on a forty-one-hour journey through America's heartland and southwest on the afternoon of 17 April 2009.

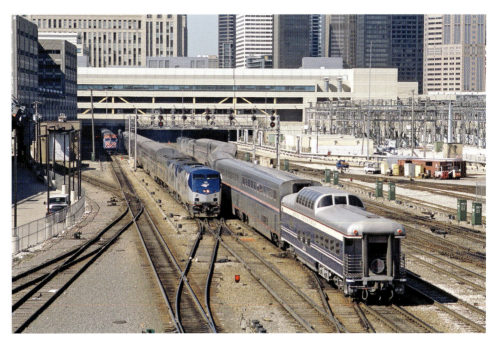

The southern throat trackage of Chicago Union Station can get busy as two long-distance Amtrak trains meet, and an inbound Metra commuter train is about to disappear into the dark depths of the station on 17 April 2009. On the back of the eastbound Amtrak is Rail Ventures' private car 'Bella Vista'.

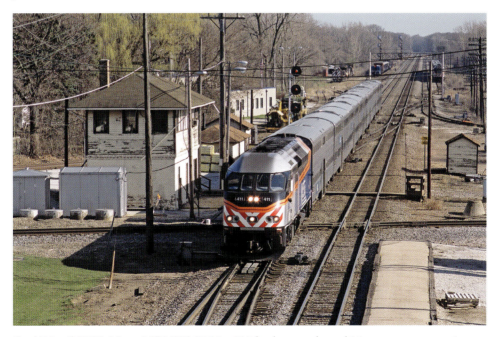

On 17 April 2009, Metra MP36PH-3S No. 411 leads a westbound Metra commuter train past the tower at Rondout on Soo Line's former Milwaukee Road main line and is clattering over the EJ&E that just became part of Canadian National.

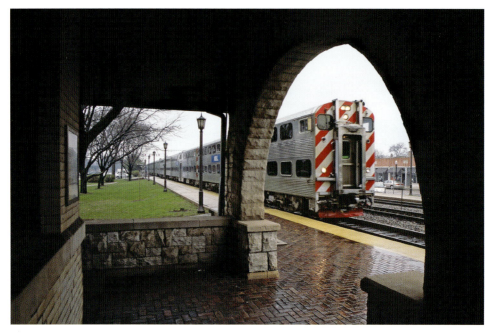

An eastbound Metra commuter train rolls toward a stop at Stone Avenue at La Grange on a rainy spring day. It was certainly nice to stay dry under the large protective eves of the station on 19 April 2009.

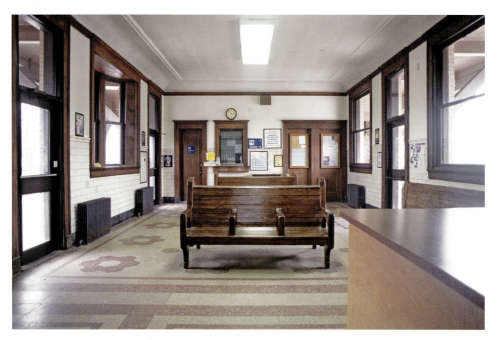

Even though the exterior of the Metra station at Stone Avenue features elegant stone arches leading to the platform lining BNSF's Chicago to Aurora main line, the interior is remarkably basic, with a pair of small wooden benches surrounded by radiators and a closed ticket office providing an adequate space for Metra commuters.

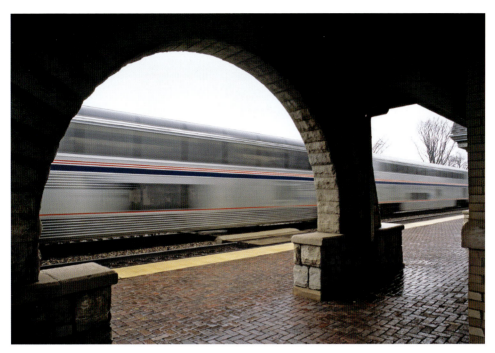

Framed by the graceful stone arches of the station at Stone Avenue in La Grange is Amtrak's California Zephyr in a blur as it speeds west on 19 April 2009.

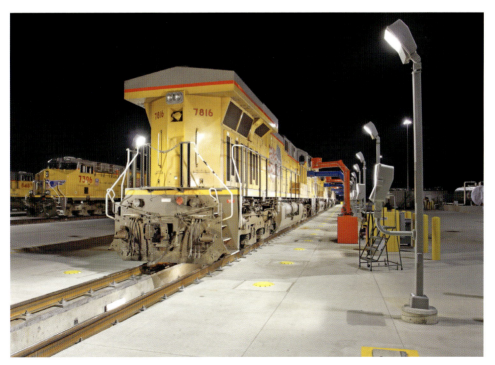

At Union Pacific's locomotive facility at the railroad's Joliet Intermodal Terminal, the service track equipped with a drop pit is well lit at night, as seen on the eve of 8 November 2010.

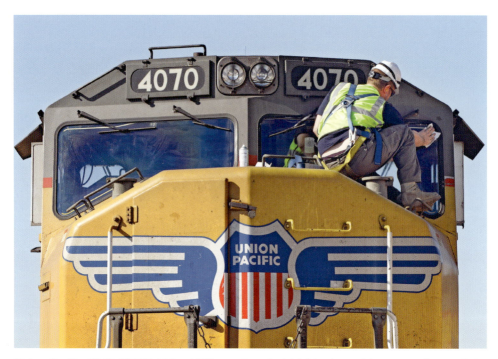

Union Pacific EMD SD70M No. 4070 gets its windshields cleaned by an employee of the locomotive service tracks at Joliet Intermodal Terminal (also sometimes known as Global IV) at Joliet on 9 November 2010.

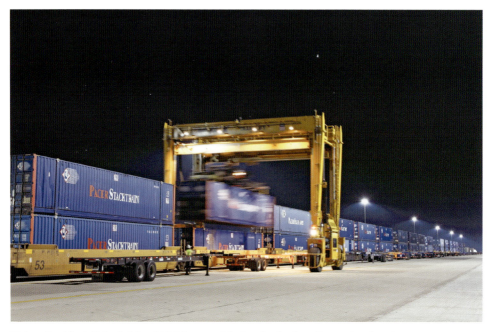

Union Pacific Mi-Jack No. 91004 smoothly loads the last Pacer Stacktrain container onto a long string of intermodal well cars at Joliet Intermodal Terminal at Joliet on the night of 9 November 2010.

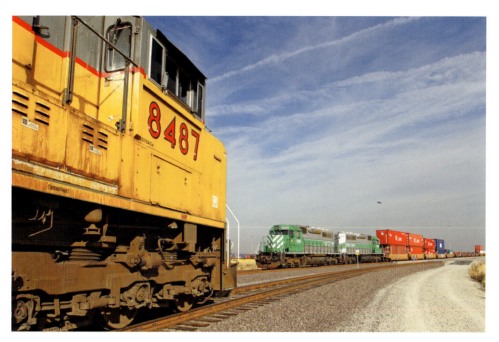

Bright green and silver First Union Rail (FURX) EMD SD40-2 Nos 3022 and 3041 switch Union Pacific's Joliet Intermodal Terminal as UP EMD SD70ACe No. 8487 looks on at Joliet on 10 November 2010.

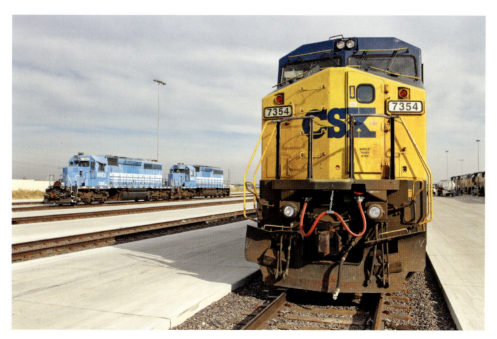

CSX GE C40-8W No. 7354, along with National Railway Equipment Leasing EMD SD40-2 Nos 7352 and 7351, sit at Union Pacific's Joliet Intermodal Terminal's locomotive facility on 10 November 2010. In previous lives, the big GE is former Conrail No. 6183, while the two blue SD40-2s are former Milwaukee Road.

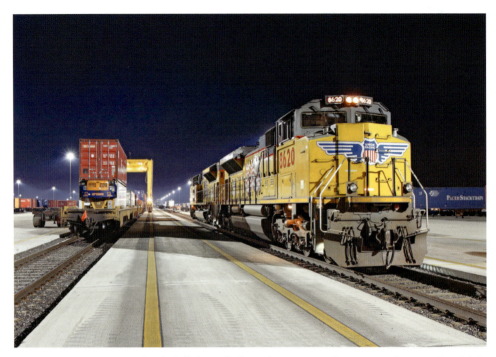

Intermodal containers are loaded all through the night as a pair of Union Pacific EMD SD70ACe locomotives rest in the yard at railroad's Joliet Intermodal Terminal at Joliet on the night of 10 November 2010.

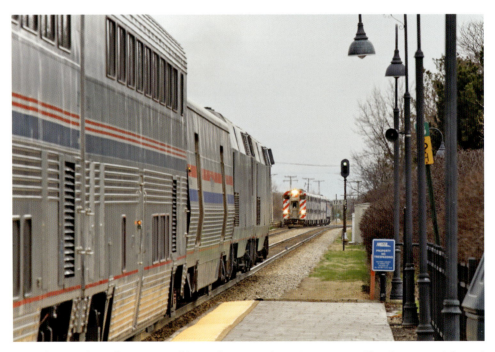

Amtrak's westbound Empire Builder makes a quick station stop at Glenview as an inbound Metra commuter train arrives on the afternoon of a gloomy 8 April 2016.

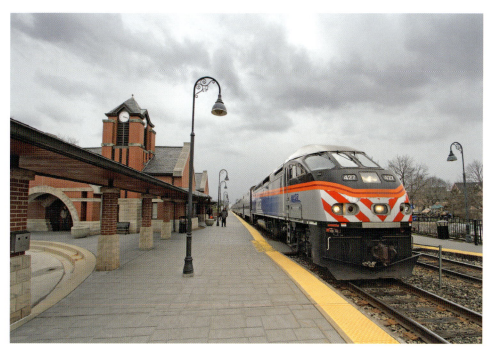

Powered by a Metra MPI MP36PH-3S No. 427, an outbound (northbound) Metra commuter train sails into Glenview station at Glenview on 8 April 2016.

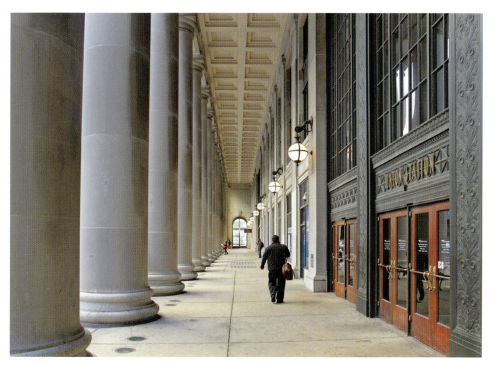

Amtrak and Metra passengers are greeted with this Canal Street entrance to Chicago Union Station, as seen on 8 November 2017.

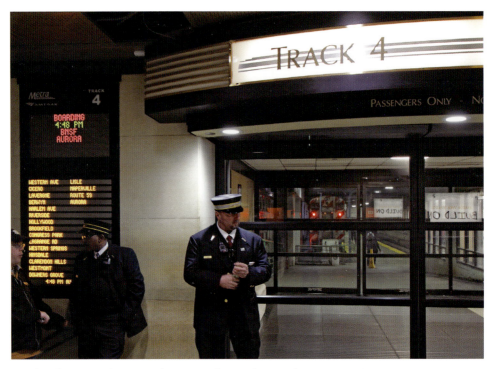

On the afternoon of 8 November 2017, the conductor of a Metra/BNSF commuter train waits for passengers to arrive and board his train parked on Track 4 at Chicago Union Station.

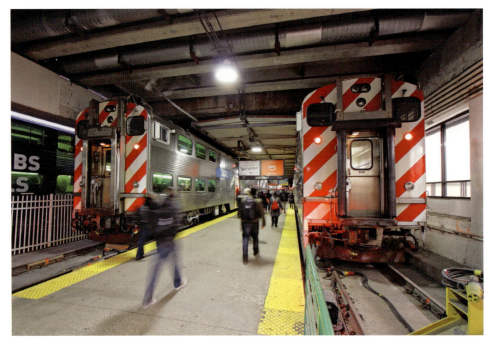

Like clockwork and the habitual beings we are, commuters rush to their trains bound for home at Chicago Union Station on the afternoon of 8 November 2017.

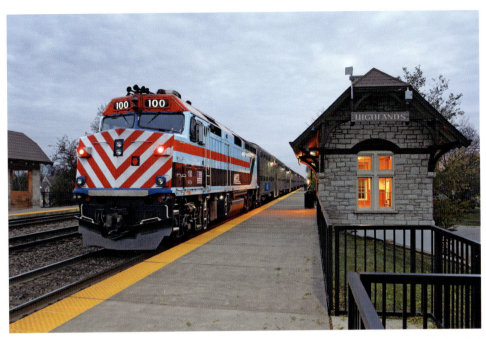

Before sunrise early on the morning of 9 November 2017, a Metra commuter train headed for Chicago pauses at Highlands, just east of Hinsdale. Powering today's train is Metra EMD F40PH-3 No. 100, specially wrapped in RTA (Regional Transportation Authority) colors worn during Metra's formative years.

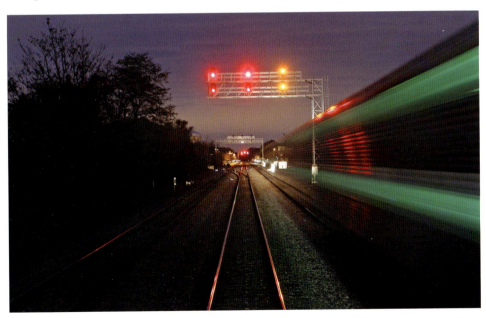

Before dawn on 9 November 2017, the glowing green windows of an eastbound Metra commuter train flies past on Track 3 as we wait on Track 2 at Naperville. The view is through the door window on the lower level of a bi-level cab car headed toward Chicago in a four-second exposure.

In a view out the lower level of a bi-level commuter cab car are the warm colors of dawn breaking on the eastern horizon as a Metra commuter train rushes toward Chicago on a high green over Track 2 at Naperville on 9 November 2017.

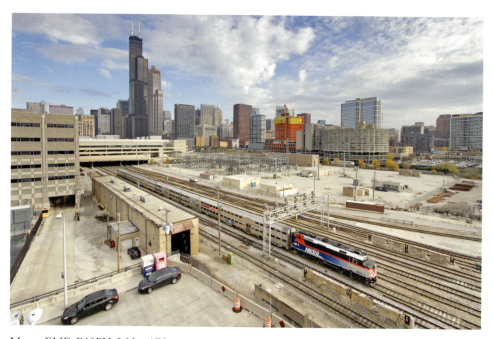

Metra EMD F40PH-3 No. 179 powers a six-car train of bi-level cars and is making its way toward Chicago Union Station with a trainload of commuters passing Taylor Street just north of Roosevelt Road on 9 November 2017.

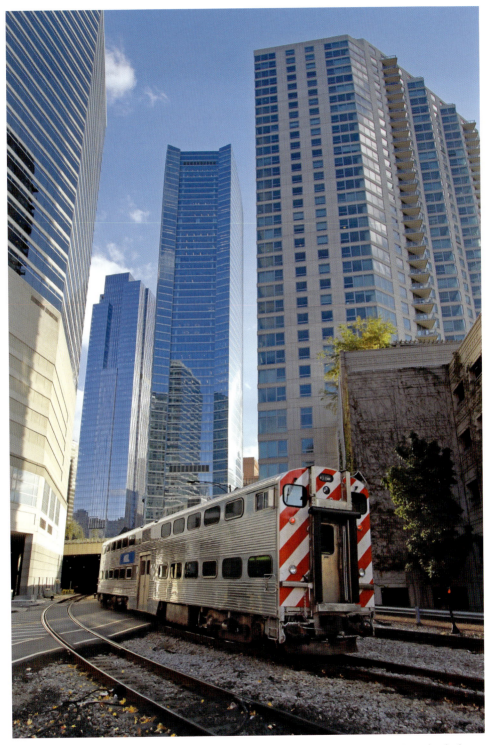

Surrounded by a few of Chicago's skyscrapers, a Metra commuter train curves into the darkness on its northern approach to Chicago Union Station on 9 November 2017.

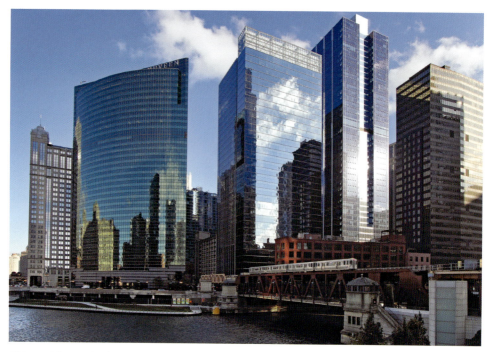

Chicago Transit Authority (CTA) is commonly known to everyone in Chicago as the 'L'. A Green Line train crosses Lake Street Bridge over the Chicago River in a canyon of metal and glass on the afternoon of 9 November 2017.

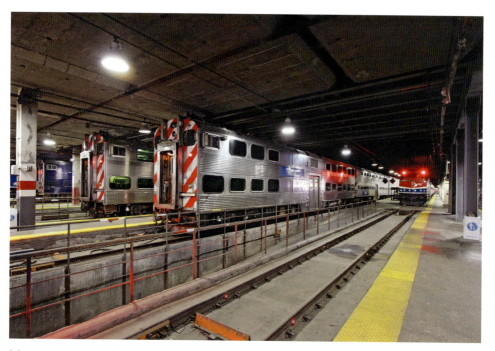

Metra commuter trains waiting to depart, as well as an Amtrak Hiawatha Service train from Milwaukee, pause on the north end of Chicago Union Station on 13 November 2017.

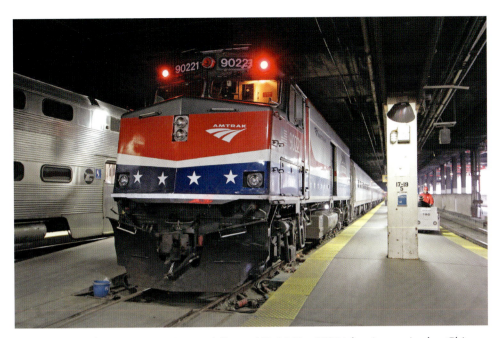

Patriotic Amtrak NPCU (Non-Powered Control Unit) No. 90221 has just arrived at Chicago Union Station with a Hiawatha Service passenger train from Milwaukee. It is specially painted to honor the men and women that have served in the United States Armed Forces. Amtrak No. 90221 was formerly an EMD F40PH that had its prime mover and traction motors removed and replaced with a baggage compartment. Paired with a locomotive on the other end of the train, the NPCU's control stand allows an engineer to operate from either end of the train, providing quicker turnarounds.

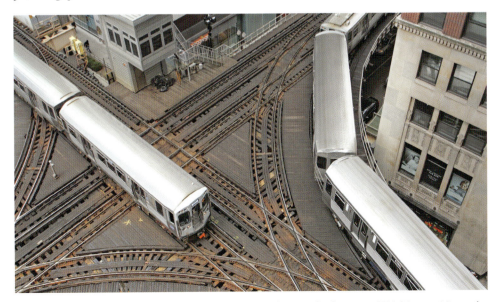

Two Chicago Transit Authority trains negotiate the interlocking at CTA Tower 18 on the elevated routes over Lake Street and Wells Street at Chicago's Loop on 8 November 2018. This railroad crossing is reportedly the busiest in the world.

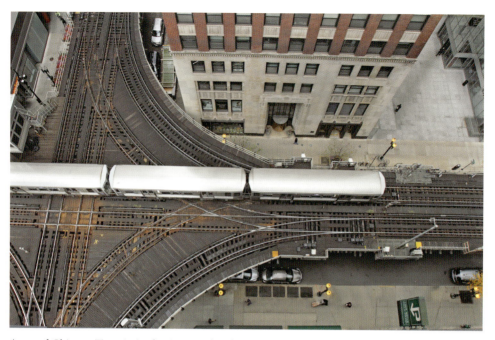

A set of Chicago Transit Authority Bombardier 5000 Series cars clatters over the diamonds at CTA's busy junction at Tower 18 on the elevated 'L' rapid transit railway above Lake and Wells Streets on 8 November 2018.

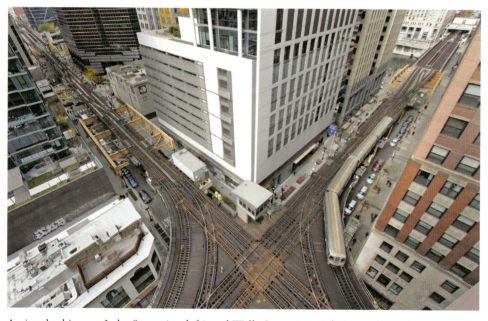

A view looking up Lake Street (on left) and Wells Street (on right) reveals a Chicago Transit Authority 'L' train heading up Wells Street on this fascinating section of elevated railway in Chicago on 8 November 2018. The CTA train made up of four Morrison-Knudsen 3200-Series cars is passing Tower 18 and about to cross the Chicago River and pause at the Wells & Merchandise Mart stop.

A Chicago Transit Authority commuter train curves along the base of century Tower at the junction at CTA Tower 18 on the elevated route over Wells Street to Lake Street in Chicago on 8 November 2018.

A Chicago Transit Authority train heads east on the elevated railway above Lake Street through a chasm of skyscrapers in Chicago's Loop on 8 November 2018.

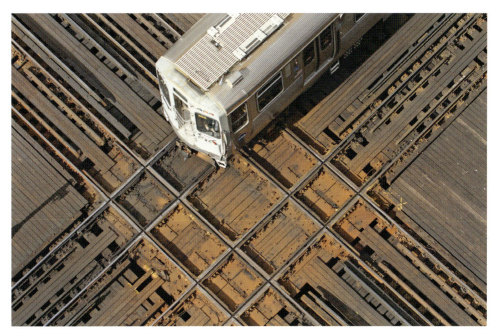

Chicago Transit Authority car No. 3450 is clattering across the diamonds on the elevated 'L' rapid transit railway above Lake and Wells Streets on 8 November 2018.

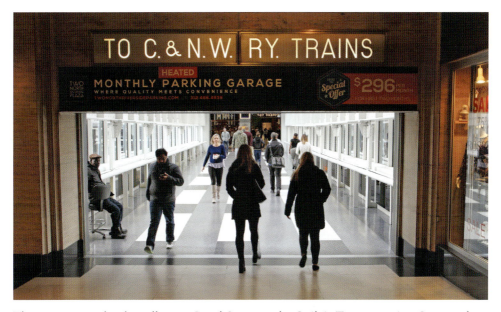

The entrance to the skywalk over Canal Street to the Ogilvie Transportation Center, where Chicago & North Western line commuter trains arrive and depart Chicago, is still labeled for C&NW over twenty years after the railway's demise. 'Union Pacific commuter trains' just doesn't sound correct anyway. In 1997, the C&NW station was named for Richard B. Ogilvie, a lifelong railroad proponent who, as governor of Illinois, created the Regional Transportation Authority, which is the parent agency of Metra that now operates all trains serving Ogilvie Transportation Center.

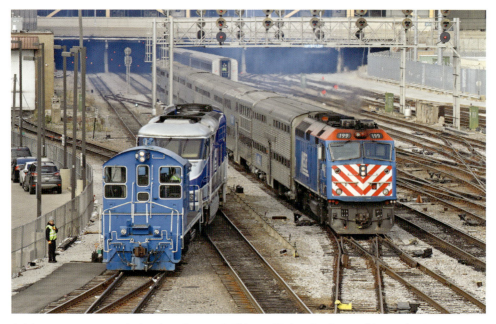

A Metra commuter train has just departed Chicago Union Station and is passing Metra EMD SW1200 No. 3 moving two newly acquired EMD F59PHI locomotives (METX Nos 73 and 77) on the lead to the north end of Metra's coach yard on 8 November 2018. In the background, an Amtrak long-distance train backs out of the dark confines of CUS and is ultimately heading for Amtrak's coach yard.

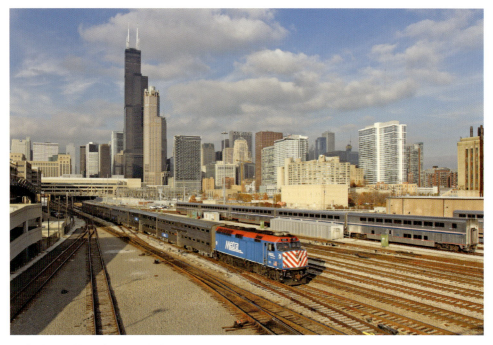

Bathed in golden afternoon light, Metra EMD F40PH-2 No. 105 departs Chicago with a load of commuters wanting to get home on 8 November 2018.

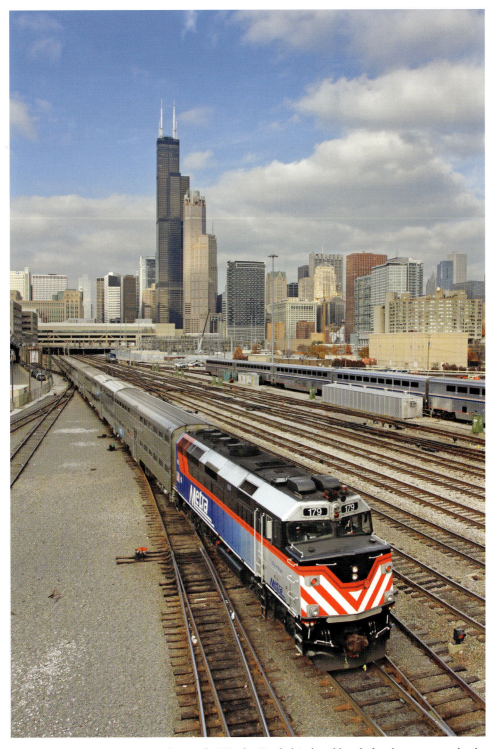

Metra EMD F40PH-3 No. 179 leaves the Windy City behind and heads for the western suburbs with another load of tired breadwinners on the afternoon of 8 November 2018.

A passenger heads for the South Concourse of Chicago Union Station in a portion of the facility 'remodeled' in 1991 on 8 November 2018. A recent renovation of the main waiting room has recently been completed, and more remodeling of CUS is apparently upcoming.

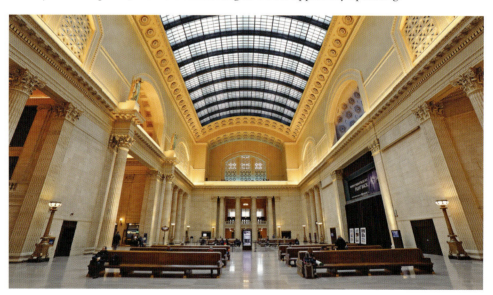

During a mid-morning lull in traffic, the Great Hall at Chicago Union Station is mostly empty and quiet on 11 November 2019. The recently refurbished Great Hall was built in 1925, and the 219-foot-long skylight has been totally rebuilt. To address the skylight's water leakage problems, each of the 2,052 pieces of glass were replaced and a new third layer of glass added above the entire opening. New high-efficiency, fully transparent glass panes replaced the current wire-embedded glass, with the end result being around 50 per cent more light pouring into the space. Some significant water damage on the walls was repaired and the entire Great Hall repainted in its original colors inside this landmarked Beaux Arts building.

BNSF EMD GP38-2 No. 2369 and EMD GP39-3 No. 2654 pull a westbound BNSF local across the Galena Boulevard overpass in downtown Aurora on a sunny 8 November 2019.

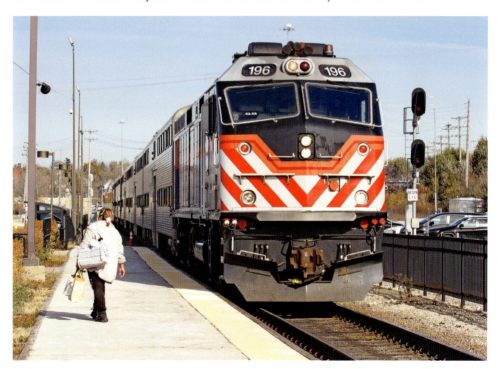

Metra EMD F40PHM-3 No. 196 and its bi-level commuter train arrive at the end of the Metra's BNSF line at Aurora on the afternoon of 8 November 2019.

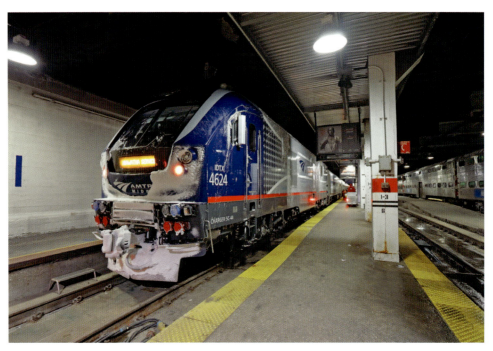

Collecting a little snow on the way south, Amtrak Hiawatha Service train 332 from Milwaukee has just arrived at Chicago Union Station behind Siemens SC-44 No. 4624 on 11 November 2019.

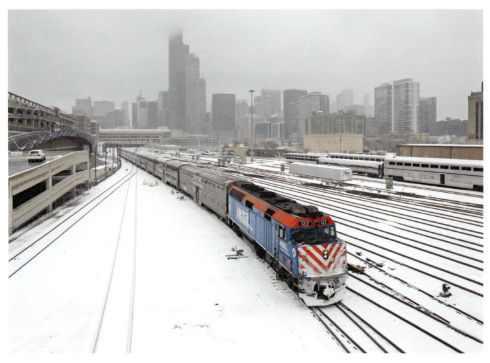

Metra EMD F40PH-2 No. 122 leads a commuter train out of Chicago Union Station towards the BNSF/Metra coach yard along Canal Street on a snowy 11 November 2019.

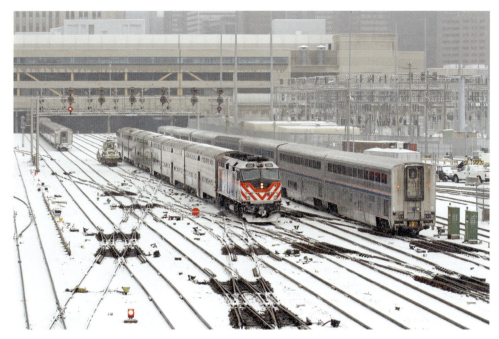

An outbound Metra commuter train, led by EMD F40PHM-3 No. 200, splits two inbound Amtrak trains at CP Taylor south of Chicago Union Station on 11 November 2019. On the left is Amtrak train 351, a Wolverine Service train, and on the right is either train 29, the Capitol Limited, or train 58, the City of New Orleans, running a bit late.

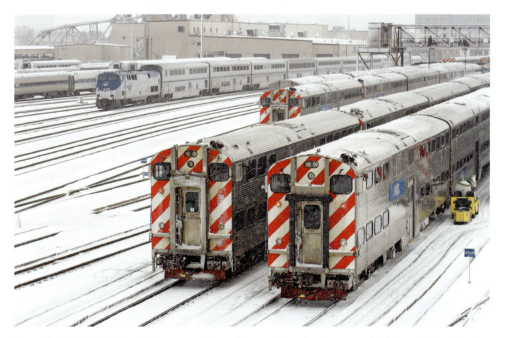

Amtrak GE P40DC No. 817 powers a Superliner-equipped train toward Chicago Union Station at Roosevelt Road on a snowy 11 November 2019. The train is passing Amtrak's coach yard in the background, as well as BNSF/Metra's 14th Street yard along Canal Street.

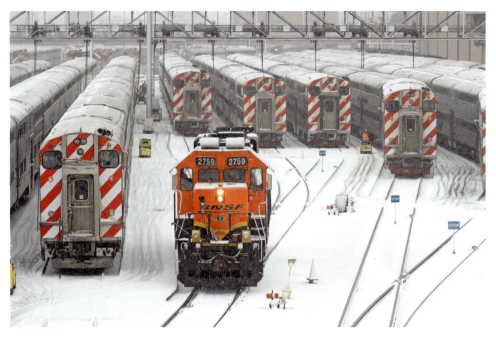

It is windy and cold, with Chicago getting between 3 and 4 inches of snow as BNSF EMD GP39-2 No. 2759 switches Metra bi-level commuter cars at the BNSF/Metra coach yard along Canal Street on 11 November 2019.

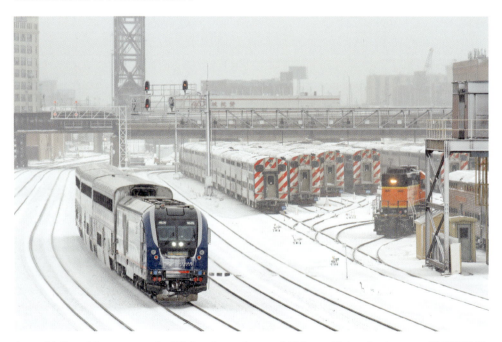

Amtrak's Pere Marquette train 371 heads south out of Chicago Union Station past BNSF EMD GP39-3 No. 2655 switching the BNSF/Metra 14th Street coach yard along Canal Street as it deadheads to the Amtrak coach yard, most likely after being turned on the wye adjoining the Amtrak locomotive facility, on a snowy 11 November 2019.